Collins

CW00732425

OBSERVING OUR SOLAR SYSTEM

Tom Kerss

Foreword by Emily Drabek-Maunder

Published by Collins
An imprint of HarperCollins*Publishers*
Westerhill Road, Bishopbriggs, Glasgow G64 2QT
www.harpercollins.co.uk

HarperCollins*Publishers*
1st Floor, Watermarque Building,
Ringsend Road, Dublin 4, Ireland

In association with
Royal Museums Greenwich, the group name for the National Maritime Museum,
Royal Observatory Greenwich, the Queen's House and *Cutty Sark*
www.rmg.co.uk

With special thanks to Emily Drabek-Maunder

A catalogue record for this book is available from the British Library

ISBN 978-0-00-853261-1

10 9 8 7 6 5 4 3 2 1

Printed in the UK by Bell & Bain Ltd

If you would like to comment on any aspect of this book, please contact us at the above address or online.
e-mail: collinsmaps@harpercollins.co.uk

 facebook.com/CollinsAstronomy
 @CollinsAstro

MIX
Paper from
responsible sources
FSC™ C007454
FSC
www.fsc.org

This book is produced from independently certified
FSC™ paper to ensure responsible forest management.

For more information visit: www.harpercollins.co.uk/green

Contents

Foreword

For thousands of years, humans have been looking up at the sky and using what they observed to keep time, predict the future, navigate Earth and uncover the true nature of our Universe. There is no denying the strong link between human history and the cosmos.

Throughout most of history, we've had to rely on our eyes to study and understand astronomy. The majority of what we can see without optical aids, like binoculars and telescopes, can be found inside our galaxy, the Milky Way. Even closer are the objects we can see within our Solar System. In addition to the Sun and Moon, we can regularly spot five of the closest planets in the night sky without a telescope: Mercury, Venus, Mars, Jupiter and Saturn. There are annual meteor showers that we can see throughout the year, the result of small pieces of asteroids and comets that burn up in Earth's atmosphere. There are more serendipitous objects in our Solar System that we can catch, like new comets illuminated by the Sun. There are also solar and lunar eclipses, occurring when the Sun, Earth and Moon line up just right.

Our understanding of space changed and evolved alongside the development of new technology. When Galileo first began observing the sky through a telescope in the 1600s, he focused his attention on nearby astronomical objects, like the Moon and planets. Using drawings, he gave humankind a first look at other worlds in our Solar System. He found that the Universe was different than how it was originally imagined. The Sun – not Earth – was at the centre of the Solar System, an idea supported by his first glimpse of Venus and its phases. Other planets had moons, like the four moons that Galileo saw in orbit around Jupiter, which are now called the Galilean moons. Telescopes allowed humans to have a closer view and deeper understanding of the Universe surrounding us.

As one of the oldest astronomical observatories in the world, the Royal Observatory, Greenwich, has played a key role in this process. When the Royal Observatory first started its work in 1676, its focus was on using the sky to aid navigation on Earth. Finding longitude was particularly difficult and sailors had to rely on unreliable methods while navigating at sea. However, the Royal Observatory helped unlock the inner workings of the Solar System by mapping the movement of the stars, planets and Moon and used them like a clock so that sailors could find their location.

Accurately predicting longitude was only a small part of the larger quest to understand our Universe. Over time, focus shifted from using astronomy to find our place on Earth to discovering the nature of the cosmos and our place within it. Astronomers at the Royal Observatory studied our Solar System and beyond, including everything from our Sun to comets, 'canals' on Mars to transits of Venus, and eclipses to binary stars.

One historical telescope used for studying the Universe was the Great Equatorial Telescope (GET), which is the largest aperture refractor telescope in the United Kingdom with a class lens that is 28 inches in diameter. This 130-year-old telescope is still in operation at Royal Observatory Greenwich today. Originally used for researching binary stars, or stars that are in orbit around one another in our galaxy, the GET is now used for public observation, giving everyone the opportunity to see the Universe for themselves. During winter months, astronomers at the Royal Observatory run 'Evening with the Stars' events for the public, observing Solar System objects like the Moon and planets currently visible in the night sky.

This is an exciting time in astronomy, especially with the possibility of one day sending the first astronauts to nearby planets in our Solar System. However, even though

widespread travel around our Solar System is still in the distant future, nothing should stop us from going out at night and pursuing our own observations of the sky. Astronomy is one of the most accessible sciences. Everyone will have experienced the feeling of the Sun on their face or seen the changing shape of the Moon at night. There is nothing that compares to seeing the planet Saturn for the first time through a telescope or managing to capture a photograph of the Moon or Mars. With the right tools and guides, anyone can learn to navigate the sky and observe all that our Solar System and beyond has to offer.

Emily Drabek-Maunder *(Senior Manager: Public Astronomy at Royal Observatory Greenwich)*

Introduction

Every star may be a sun to someone.
Carl Sagan

The Solar System comprises the Sun and a vast number of orbiting worlds ensnared by its gravitational influence – most of which are practically just pieces of debris by comparison to their host star. A small number of the most significant objects, including our planet Earth, can be considered environments of their own, but most are lifeless fragments – leftovers from a turbulent birth some billions of years ago. This system operates on a scale that vastly exceeds our everyday experience, yet viewed against the expanse of the Galaxy beyond, it seems remarkably local. So, cosmically speaking, the Solar System is the region of space most appropriately termed our 'neighbourhood'. As with our earthly neighbourhoods, it is as familiar to us as it would be foreign to a visitor from another star system, and just as we take an interest in the buildings that share our streets,

astronomers scrutinise the behaviour of the planets, their many moons, and countless other companions of the Sun.

Centuries of insatiable curiosity and pioneering spirit have delivered an extraordinarily rich picture of the Solar System. We live at a time when spacecraft have completed the reconnaissance of the planets, robotic emissaries have landed on numerous other worlds, and enormous surveys continue to chart the most remote reaches of the outer Solar System to astonishing distances. There remain yet more questions than answers, but the wealth of knowledge gained so far greatly enriches our observing experience, lending context to the small images in our telescopes, and allowing us to predict spectacular events with surgical precision. In concert with these scientific advances, affordable telescopes and eyepieces of excellent quality have become ubiquitous. We can all follow in the footsteps of early trailblazers like Galileo, whilst enjoying a much clearer view than they could have imagined possible, and with a surprisingly low cost of entry.

This book's purpose is to serve as your personal guide to Solar System observation, and support your ambitions whatever they may be. It could be that you intend to become a skilled visual observer with a subject focus on the planets or the Moon; perhaps you'd like to chase down comets and follow their progress to possible greatness; maybe you hope to make your own high-resolution images revealing details and colour beyond the reach of the eye – there are many avenues to exploring our neighbouring worlds. My advice is based upon many years of experience as a keen visual observer and astrophotographer, who has been fortunate enough to witness almost the complete checklist of 'must see' Solar System highlights, including events that occur only once or twice in several generations. I hope that it will steer you well on your journey to mastering your cosmic neighbourhood.

To maximise the practical value of this guide, I have curated the text to emphasise information fundamental to observation. Naturally, some scientific insight into the objects we're looking at will enhance the experience and better prepare us to make the most of our equipment, but this will only be included insofar as it is useful. As such, we will not explore Solar System objects in exhaustive scientific detail – that would entail a much thicker and heavier book! After a short summary of the observational history and discovery of the Solar System, we'll briefly explore its formation, structure, size and motion. Then we'll look at resources that enable accurate forecasting of positions of Solar System objects and timings of special events. From here, we can begin to dissect the various categories of these objects and events for a granular look at how best to observe them, but not before a discussion about the limits of the naked eye and the importance of optical aid. Many wonderful sights can be enjoyed by eye alone or with modest binoculars, but the in-depth portions of this guide will be better suited for telescopes. In some cases, telescopes are essential for observations to be possible. Following a guide to telescope designs and accessories, their practical limits and the atmosphere, we'll look in detail at the planets and Moon, the Sun, minor planets including asteroids and comets, and finally special events such as eclipses, occultations, transits and conjunctions. The closing chapters cover Solar System imaging, with a broad overview of theory and equipment, followed by example workflows that illustrate different approaches to various targets.

I wish you enduring clear and steady skies for many exciting nights at the eyepiece of your telescope. Let it carry you upwards and connect you to other worlds.

1: HISTORY OF SOLAR SYSTEM OBSERVATION

Prehistory

It is not difficult to close your eyes and bring to mind the image of another planet like Mars or Saturn. We grow up with a clear impression of how these worlds appear from space-probe imagery and informed artists' impressions. But the familiarity we enjoy has existed for just a few short centuries – a vanishingly small fraction of the human timespan. For most of human history, our ancestors regarded the Solar System with a mixture of bewilderment and superstition. That is not to say that there were no important milestones of understanding before the advent of the telescope, but the pace of discovery since the early 17th Century virtually eclipses literally tens of thousands of years of speculation that preceded it.

We can only speculate about what early humans thought about the objects and events in the Solar System.

Strictly speaking, there is no prehistoric model of the Solar System, because the concept did not exist in human thought about the natural world. Early humans regarded the ground and the sky as two entirely different domains – the latter being forever out of reach – and this likely brought them comfort when strange, inexplicable things occurred up there. In that vast gulf of unrecorded time, people witnessed eclipses of the Sun and Moon, the arrivals and departures of comets, and dazzling meteor storms, but in their rarity, many of these events will have become mythology within just a few generations. Surviving observations from this period are sparse and subject to considerable speculation.

Antiquity

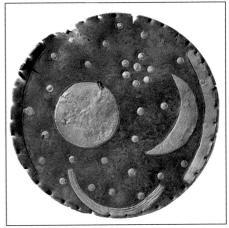

The Nebra Sky Disc depicts the Moon alongisde stars, possibly including the Pleiades cluster, as well as the Sun.

Artefacts from the Bronze Age, such as the Nebra Sky Disc, speak to the growing importance with which ancient people considered the sky at this time, and their fascination with it would have a profound impact on the emerging philosophies of the natural world. The ancient Greeks devoted a great deal of attention to understanding the workings of the heavens, with a special focus on the asteres planetai ('starry wanderers'). It is from this phrase that we get the modern word planet, meaning wanderer, and during the antiquity, the five visible to the unaided

English (Germanic or Nordic)	Latin	Classical Planet
Monday	Dies Lunae	Moon
Tuesday (Týr)	Dies Martis	Mars
Wednesday (Woden)	Dies Mercurii	Mercury
Thursday (Thor)	Dies Joves	Jupiter
Friday (Frigg)	Dies Veneris	Venus
Saturday	Dies Saturni	Saturn
Sunday	Dies Solis	Sun

Days of the week with their corresponding Latin names and classical planets.

eye (Mercury, Venus, Mars, Jupiter and Saturn) were grouped with the Sun and the Moon to form the group of seven classical planets. This scheme is immortalised in the names of the days of the week, which originate from this period.

Understanding cosmology was a central pursuit for many generations of prolific Greek philosphers in the ancient world.

Of course, today we understand planets to be mechanically different from the Sun and Moon, but to ancient people they were associated by their common ability to move through the sky among the 'fixed' stars. Greek astronomers such as Plato committed much thought to the cause of this special behaviour, whilst the chiefly superstitious generally regarded them as deities. Centuries after Plato's time, the Greek polymath Ptolemy published his seminal work – the Almagest. It contained an early attempt at arranging the Solar System in a series of orbits, building upon the ideas of Aristotle.

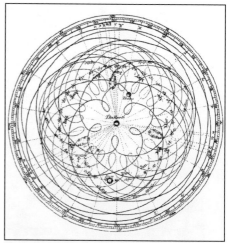

Ptolemy's Almagest ('Great Work') included a geocentric model of the Universe.

Ptolemy's model was sophisticated, and prevailed for over 14 centuries, but he was fundamentally mistaken in placing the Earth at the centre of the Solar System. As such, he

had to correct for deviations in the positions of the planets by placing them on smaller paths within their orbits. Remarkably, a model with the Sun at the centre had been proposed centuries earlier by Aristarchus of Samos. In retrospect, we can see how far ahead of his time he was, but his ideas of a heliocentric cosmology failed to gain support in the ancient world. For most, it was simply easier to accept that the Earth held a special importance, and did not move.

The Copernican Revolution

By the 16th Century, astronomers were sitting on a wealth of data about the Solar System – tables that had been made by skilled observers. Considering the fact that the telescope had not yet been invented, the accuracy of these observations is a marvel. In 1543, the Polish astronomer Nicolaus Copernicus shocked the scientific world with his publication of a robust, heliocentric theory of the Solar System, placing the Sun at the centre and resolving many issues with the Ptolemaic model. It was supported by the best observational evidence available, and triggered what has become known as the Copernican Revolution – a dramatic shift in the application of mathematics in astronomical investigation.

Copernicus was precisely correct in his solution, but the adoption of his model came reluctantly for those who could not abandon the notion of the Earth being central to the Cosmos. The prolific Danish astronomer Tycho Brahe, one of the last great observers of the pre-telescope era, developed his own system, in which the planets were allowed to orbit the Sun, and the Moon allowed to orbit the Earth. But in his view, the Sun also orbited the Earth. The Tychonian system was excessively complicated, but fortunately one of his own students – a freethinking young German called Johannes Kepler – would be drawn back to the elegance and simplicity of Copernicus in the years after Brahe's death.

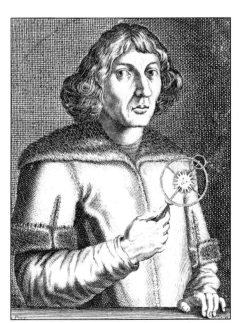

Portrait of Nicolaus Copernicus, who proposed a revolutionary heliocentric model.

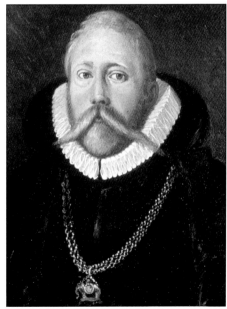

Tycho Brahe sought to unify the Copernican and Ptolemaic systems, resulting in a complicated model.

The Telescope

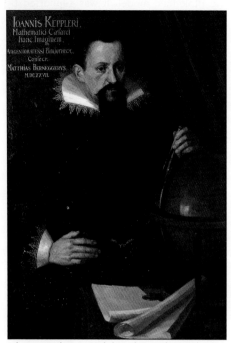

Johannes Kepler was Brahe's student, and enjoyed unrivaled access to his world-class observation tables.

Hans Lipperhey's telescope, which used lenses to form and magnify an image, was utterly transformative to astronomical science.

At the turn of the 17th Century, Tycho Brahe passed away, leaving Kepler to continue his work with his superb trove of observational data. He had for years been struggling to reconcile the motion of Mars with the Tychonian system, and had long suspected that Copernicus offered the better solution. Holding a prestigious position, whilst moonlighting as an astrologer, Kepler turned his brilliant and creative mind to a complete understanding of celestial mechanics. In 1608, something happened which no living astronomer could have expected. A Dutch lens-maker called Hans Lipperhey submitted a patent for a refracting telescope, which could magnify the appearance of distant objects. It is unclear whether he invented the device himself, but word of the patent spread rapidly through the academic community.

Early in the following year, the English scientist Thomas Harriott purchased one, and on 26 July that same year, pointed it at the Moon, making the first known astronomical observation with a telescope. Over four months later, Tuscan polymath Galileo Galilei had constructed his own version of Lipperhey's design, and would become the first astronomer to resolve the planets. His drawing of the phases of Venus has become one of the great images from the history of science.

Alongside these two pioneers was Johannes Kepler, who acquired his own telescope (borrowed from a Duke, no less) and engaged in written correspondence with Galileo. The two evaluated each other's works, and published truly ground-breaking insights about the nature of objects that had drifted over the heads of humans since time immemorial, and yet had never been seen for what they were. It is hard to imagine a more exciting technological

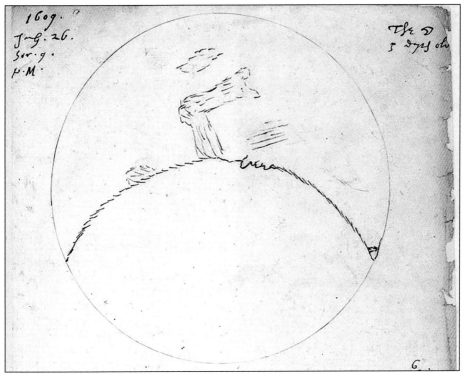

Thomas Harriott is credited with the first known astronomical observation through a telescope – a sketch of the Moon during its waxing crescent phase.

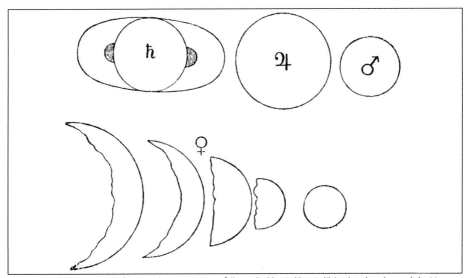

The phases of Venus, never before seen by eye, were carefully studied by Galileo Galilei, who also observed the Moon, stars and other known planets with his telescopes.

Herschel's reflecting telescope, based upon Isaac Newton's design, which was used to discover Uranus from his home in Bath.

mirrors rather than lenses to focus light. In the decade that followed, Kepler would publish his three laws of planetary motion, forever cementing him in history as the first real astrophysicist. His laws were used in ways he could never have imagined – to send people to the Moon, and to discover worlds orbiting other stars.

Over four centuries, larger and larger telescopes have been employed to discover more and more of our Solar System. In 1610, Galileo's primitive telescope allowed him to see the four largest moons of Jupiter. In 1781, English astronomer William Herschel discovered the planet Uranus – the first planet to be found by a telescope. In 1801, Italian astronomer Giuseppe Piazzi discovered Ceres, which would later be considered the first known asteroid and one of the few dwarf planets in our solar system. So advanced were observations of Uranus, that known perturbations in its orbit inspired predictions about the existence of Neptune, which was confirmed using a telescope in 1846. In 1930, the American astronomer Clyde Tombaugh, after years of searching, found Pluto. Along the way, moons, asteroids, comets, solar storms, and many remarkable planetary features were found, studied and debated.

leap for any other discipline. The telescope unlocked the sky as never before, and triggered an age of discovery that we are still living through today. Kepler actively improved the design of the refracting telescope, and many astronomers who followed would do the same – notably, Isaac Newton developed a design that used

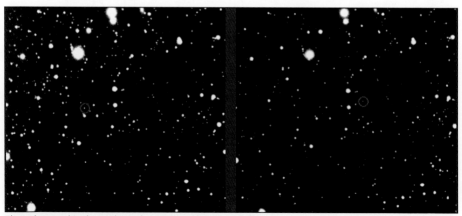

These photographic plates taken 6 days apart on 23 January (left) and 29 January 1930 (right) revealed the motion of Pluto (circled) to Clyde Tombaugh.

The telescope allowed Galileo to see Neptune in 1612, but he believed it to be a star. It was not officially discovered for another 234 years.

In some ways, the telescope was almost too powerful for the expectations of its early adopters. Galileo, for example, observed Neptune well over 200 years before it was predicted to exist. In 1690, the English astronomer John Flamsteed observed Uranus from the Greenwich Observatory. Neither realised they were seeing new planets, because few even expected the Solar System to continue beyond what was known from antiquity.

Today's telescopes look somewhat different – some are true wonders of the modern world – but many observers (the author included) still choose the humble refractor, not much different from its ancestor of the early 17th Century, to enjoy views of the Solar System today.

The Space Age

Less than three decades after the discovery of Pluto, humans had developed the capacity to send robots to the Moon. The Space Age yielded new opportunities to understand the Solar System. We no longer merely peered out at these worlds; our robotic emissaries were destined to visit them.

In December 1962, the US *Mariner 2* spacecraft made the first flyby of another planet – our nearest neighbour Venus. Less than three years later, in July 1965, *Mariner 4* would sail past Mars. For the first time in

The soviet Luna 3 spacecraft captured and returned images of the far side of the Moon in 1959 – it had never been seen before.

human history, we could gaze down upon the landscapes of our neighbouring planets and appreciate their true scale. The US would focus its efforts on Mars landings, resulting in the Viking programme. The two identical and highly successful *Viking* probes successfully landed on Mars in 1976. Along the way, they found time to send *Mariner 4* to Mercury in 1974, completing the initial reconnaissance of the inner Solar System.

The USSR had achieved a technically successful, if generally ill-fated Mars landing in 1971 with *Mars 3*, and turned its attention to Venus. The Venera programme yielded ten successful touchdowns on the hellish second planet. The early 1970s also

The first close-up images of Mars came from Mariner 4, leading the way towards a landing programme.

The soviet Mars 3 mission made the first soft landing on Mars in 1971, but the programme faced many failures. NASA's Viking landers arrived in 1976, and returned astonishing images in full colour.

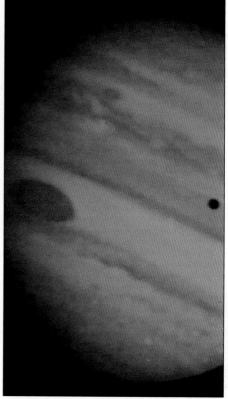

Jupiter's extraordinary storms, including the Great Red Spot, were seen like never before when Pioneer 10 arrived in 1973.

The Venera program, which ran from 1961–1984, made ten successful landings, descending through the cloudy atmosphere to send back images of the Venusian surface.

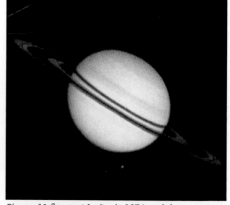

Pioneer 11 flew past Jupiter in 1974, and then encountered Saturn in 1979, exploring its stunning rings up close.

Voyager 2 is the only spacecraft to have visited the Ice Giants, passing Uranus in 1986.

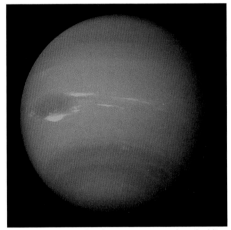

In 1989, Voyager 2 flew by Neptune, more than doubling the number of moons known to orbit the planet.

These interplanetary missions resulted in the discoveries of many more moons and intriguing features, and prompted the development of dedicated orbiters such as *Galileo* (Jupiter, 1995) and *Cassini* (Saturn, 2004). The latter deployed a lander, *Huygens,*

saw the launches of *Pioneer 10* and *Pioneer 11*, two US probes that would return close-up images of both Jupiter and Saturn before the end of the decade. The Voyager missions, launched in 1977, took advantage of the favourable positions of the two Gas Giants to visit them both, and *Voyager 2* was re-routed to Uranus in 1986 and Neptune in 1989. The Ice Giants – two of the most remote worlds in the Solar System – had been visited less than 42 years after the launch of the first satellite.

The Huygens lander descended through Titan's hazy atmosphere in 2005 and transmitted images from its surface.

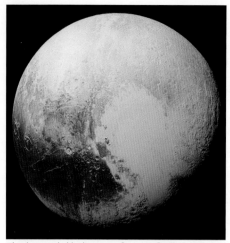

Pluto's remarkably diverse surface was finally revealed in 2015 by the New Horizons probe. Its heart-shaped feature delighted fans of the former planet.

which touched down on Saturn's largest moon, Titan in 2005 – the first landing on a non-terrestrial satellite. Meanwhile, throughout the 90s, new worlds were catalogued in the far reaches of the Solar System, beyond the orbit of Neptune. They hinted at an expansive unknown region – the Kuiper Belt – which included Pluto. Evidently, Pluto had more in common with these worlds than the rest of the planets, and its fate was sealed long before it was reclassified as a dwarf planet in 2006.

Nevertheless, exploration of Pluto was a long-held dream for planetary scientists, and in 2007 the *New Horizons* spacecraft was launched to visit it. In 2015, the flyby occurred, and the nine planets that most had grown up with had now been explored. It was certainly a defining moment, but we should not overlook the many other worlds that have also been visited. Asteroids, comets and even the Sun have become the home – temporarily or permanently – of human-made probes, and although our impact has been small, in some ways we have become a multi-world species.

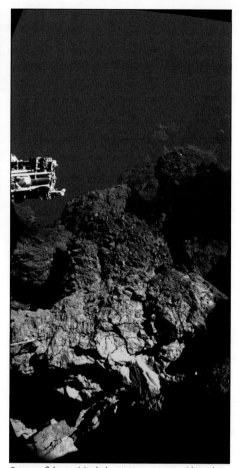

Spacecraft have visited planets, moons, asteroids and even comets. In 2014, the European Rosetta probe dispatched the Philae lander to the surface of comet 67P/Churyumov-Gerasimenko.

The acquisition of ground-based and space-based observations of both known and new worlds is ongoing, and indeed the pace of this research is accelerating. It seems that there is more out there yet to be discovered than everything we know about so far, and we are still in the early stages of the full history of human exploration of the Solar System. If the subject of this book inspires you, perhaps you will become a part of the story that is yet to be written.

2: UNDERSTANDING THE SOLAR SYSTEM

Formation

We see the Solar System today in a mature state of relative calm. The Sun and its companions lead orderly and fairly uneventful lives, but things weren't always this way. The Solar System has a tumultuous history, the details of which have been gradually distilled by many generations of astronomers. Imagine arriving at the scene of a murder, with obvious signs of a struggle, and trying to determine exactly what happened. A good detective would gather evidence – such as fingerprints or hair fibres – and use reasoning to try and figure out how the events leading up to the crime played out. Likewise, astronomers gather observations, samples and employ mathematics to work backwards from the Solar System as we see it now to its distant origins. Naturally, the further we reach into the past, the hazier our picture becomes. But in the modern age of computational astrophysics, inferences about the Solar System's initial formation (as well as its billions of years of evolution) can be tested against sophisticated models, providing varying degrees of confidence that depend upon the level of theoretical detail.

The Sun was born cocooned in a cloud of gas that was itself distilled from a large nebula.

Astronomers, planetary scientists and astrophysicists have determined that the Solar System formed approximately 4.6 billion years ago from the collapse of a large nebular structure – a cloud of material many light-years in diameter. Models suggest that a cloud more than 60 light-years wide underwent fragmentation, as dense pockets spanning a few light-years appeared within it. At such scales, the dominant force is gravity – a one-way, attractive force that compels matter to clump together. One of these fragments became the presolar nebula, from which the Sun was born. Relative to the rarefied nebula around it, this collapsing bubble was very dense and measured approximately 10,000 Astronomical Units (AU). This unit is a measure of the average distance between the Earth and the Sun today, and whilst 10,000 times that distance might seem enormous, it is *only* (!) 0.15 light-years. On the scale of the Galaxy, the dense core that would become our Solar System was very tiny.

As the presolar nebula continued to collapse, its initially gentle rotation sped up. This is due to a physical law we know as the conservation of angular momentum, and the same effect is seen when an ice-skater brings their arms close to their body to spin more rapidly. Another physical law states that when a gas is subjected to greater pressure, it increases in temperature. With the atoms having less free space between them, they collide and interact more often. This in turn converts their kinetic energy into heat, which effectively raises the temperature of the gas. In this way, the presolar nebula rotated ever faster and became ever warmer – particularly at the centre, where most of the matter was situated. Over a period of about 100,000 years, the fragmented core formed into a flattened disc of rotating material just 200 AU in diameter. At its heart was a spherical protostar – the Sun, but not yet undergoing the process of nuclear fusion in its core. Surrounding it was the protoplanetary disc from which the planets would eventually form.

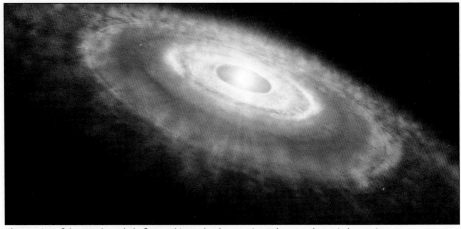

The rotation of the presolar nebula flattened it, as the slow moving poles were drawn in by gravity.

The initial presolar nebula was roughly spherical in shape, but it became approximately flat due to its rotation and the forces acting on it. Gravity was still the most significant force, but magnetic fields also played a role. At small scales, particles of matter in close proximity are much more sensitive to magnetic influence than gravity. The spinning, disc-shaped cloud that would become our Solar System had a compositional make-up very similar to that of the Sun. It was mostly hydrogen, partially helium and lithium, with these three elements collectively making up about 98% of its mass. The remaining 2% consisted of heavier elements, which are the products of mature stars. Previous generations of stars had enriched the presolar nebula, which also contained recently generated, unique products from a cataclysmic star death known as a supernova. Astronomers believe that a nearby supernova shockwave may have triggered the process of fragmentation that led to the formation of the Sun and its siblings.

After its formation, the young protostar gradually heated up as material from the surrounding disc accreted onto it, increasing the pressure in its core. Eventually, after tens of millions of years, the core achieved a temperature and pressure high enough for individual hydrogen ions (protons) to be fused together. Ordinarily, these ions would repel each other, but at extremely high temperatures, they can overcome the force that acts to keep them apart. This mechanism – nuclear fusion – releases extraordinary amounts of energy, and it caused a runaway reaction which was sustained by the considerable gravitational force still exerting pressure on the Sun's core. In effect, the gravitational collapse and pressure from the nuclear engine of our star are balanced. When the Sun began to shine, its energy radiated into the protoplanetary disc, not only as light, but also in the form of stellar wind that would eventually blow away most of the unbound material in the disc over a period of a few million years.

Fortunately, the formation of the planets began long before the Sun switched on and cleared out the Solar System. After reaching a sufficient density, the presolar nebula underwent a kind of fragmentation of its own. Small, dense regions emerged as material within the disc formed into tiny grains, which subsequently collected together into larger ensembles resembling small rocks. This process, called coagulation, was at first directed not by

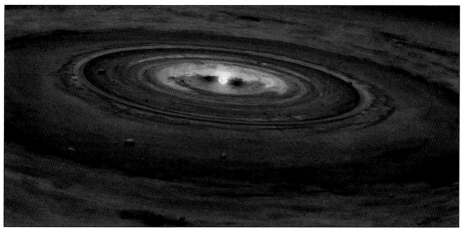
Dozens of protoplanets emerged in the disc of debris around the young Sun.

gravity, but by electrostatic attraction and magnetic fields within the disc. As the tiny dust grains assembled themselves into larger pieces, gravity played an increasingly important role. The inner region of the disc, close to the protostar, became too hot to accommodate volatile molecules – those which vaporise readily. Water, methane and ammonia could only condense much farther away, so objects that formed close to the centre of the nebula were composed largely of silicates (rock) and metals with high melting points, such as iron. Meanwhile, past a distance of about 5 AU from the protostar – a boundary called the snow line – volatile compounds settled in icy grains. The result is two distinct but broad categories of planets. The four innermost planets – Mercury, Venus, Earth and Mars – are predominantly rocky, whereas the four outermost planets – Jupiter, Saturn, Uranus and Neptune – are largely composed of ices and gases. It is thought that initially, hundreds of competing 'planetesimals' or infant planets jostled for a place in the Solar System. Many collided and were destroyed, leaving behind fragments that still orbit the Sun today. Others were ejected from the Solar System, and some may have been captured as satellites of larger worlds that were further along in their development.

The 'terrestrial' planets, so called because they are small and rocky like the Earth, are believed to have migrated inwards having formed farther away from the Sun. The disc of gas and dust around the young Sun did not rotate as fast as the orbits of the planets, and the resulting drag altered their momentum. This is, of course, fortunate for us, as the Earth now occupies a coveted spot in the Solar System's 'Goldilocks zone' where the temperature allows liquid water to be sustained without crushing atmospheric pressure. Models suggest that the Ice Giant planets – Uranus and Neptune – migrated in the opposite direction, away from the Sun, and may have swapped places with one another several hundred million years after the formation of the Solar System.

Around 200 million years after the Earth's formation, scientists think it was struck by a Mars-sized protoplanet in a head-on collision, which ejected material from both worlds into a ring around the younger Earth. The impactor, called Theia, was destroyed by the event, after which the ring of debris gradually coalesced into the Moon – an unusually large satellite for such a small planet as ours. As the protoplanetary disc began to dissipate, the rest of the Solar System started to take the shape we see it

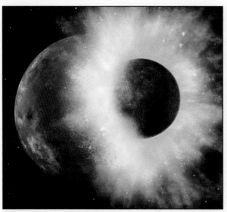

A significant protoplanet called Theia collided with the proto-Earth. The impact resulted in the formation of the Moon, which is strikingly similar in composition to the Earth's crust.

in today. Planetary orbits were smoothed out and stabilised by drag, whilst unused material from failed protoplanets was tidied up. Jupiter, with its tremendous gravitational influence, played a significant role in shepherding the formation of the Main Asteroid Belt from dozens of Moon- to Mars-sized planetesimals that were destroyed in collisions. Meanwhile, the large planets captured asteroids as satellites. This process was chaotic, throwing a great deal of material out of the asteroid belt and into the inner Solar System, creating a long period of bombardment, the scars of which are seen on the Moon's uneroded surface today. However, this period was also crucial to our existence, as it is thought that water-rich asteroids and comets from the Jupiter region helped to deliver the water that today covers most of the Earth's surface.

There are still many details about the Solar System's evolution that remain hazy or entirely mysterious to us, but the increasing pace of scientific study will bring the answers, and no doubt some surprises. If your experience of studying the Solar System as an amateur inspires you, then perhaps the scientific research we need to piece together its history is in your future!

Structure and Size

Having formed from the flattened protoplanetary disc, the planetary system appears approximately flat as seen from a large distance. The orbits of the planets are not situated exactly on the same plane – they are each inclined from one another and with respect to the Sun's equatorial plane – but the disparity between them is quite small. There are no planets that orbit over the Sun's poles, but there are plenty of objects with highly inclined orbits. Beyond the small, exclusive group of surviving planets, there is a much larger collection of minor planets, including dwarf planets and asteroids, as well as comets.

As we have seen in the previous chapter, the planets are arranged into two broad categories, with the rocky 'terrestrial' planets being closest to the Sun, and the large Gas Giant (and Ice Giant) planets lying much farther out. The giants are all vastly bigger in size than the terrestrial planets, and so too are the distances between them. At their minimum separations, the terrestrial planets are tens of millions of miles apart, whereas the Gas Giants and Ice Giants are hundreds of millions of miles apart. For simplicity, distances from the Sun are often given in Astronomical Units (AU) where one AU is the average distance between the centre of the Earth and the centre of the Sun, equal to 92.96 million miles (149.6 million km). The table contains basic data about the seven planets: their size relative to the Earth, orbital period, and maximum apparent brightness and size. Brightness is given in the astronomical magnitude scale, where smaller numbers and negative numbers indicate higher brightness. Each integer magnitude corresponds to about 2.5× more brightness, so a magnitude 1 object is about 2.5× brighter than a magnitude 2 object, and about 6.25 times brighter than a magnitude 3 object. The limiting magnitude for the unaided, fully dark-adapted eye is typically between 6 and 6.5 in ideal conditions.

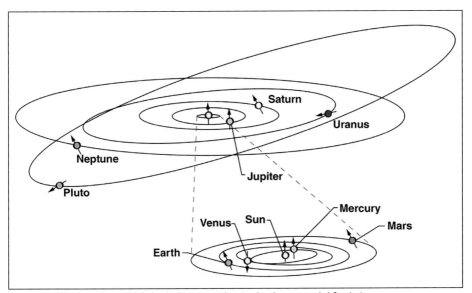

The orbits of the eight planets (and Pluto). The terrestrial region has been expanded for clarity.
The direction of each object's north pole is indicated by an arrow.

Name	Type	Average distance from the Sun	Diameter	Orbital period	Max magnitude	Max angular size (arcseconds)
Mercury	Terrestrial	57,910,000 km 36,000,000 miles 0.387 AU	4,800 km 2,983 miles 0.383 Earths	88 days	−2.45	13.00
Venus	Terrestrial	108,200,000 km 67,200,000 miles 0.723 AU	12,100 km 7,519 miles 0.949 Earths	225 days	−4.89	66.00
Mars	Terrestrial	227,940,000 km 141,600,000 miles 1.524 AU	6,800 km 4,226 miles 0.532 Earths	1.88 years	−2.91	25.13
Jupiter	Gas Giant	778,330,000 km 483,600,000 miles 5.203 AU	142,800 km 88,736 miles 11.21 Earths	11.86 years	−2.94	50.59
Saturn	Gas Giant	1,424,600,000 km 885,200,000 miles 9.523 AU	120,660 km 74,978 miles 9.45 Earths	29.46 years	−0.49	21.37
Uranus	Ice Giant	2,873,550,000 km 1,785,600,000 miles 19.208 AU	51,800 km 32,189 miles 4.01 Earths	84.01 years	5.32	4.08
Neptune	Ice Giant	4,501,000,000 km 2,796,900,000 miles 30.087 AU	49,500 km 30,759 miles 3.88 Earths	164.8 years	7.78	2.37

Angular size is given in arcseconds, where 60 arcseconds make up one arcminute, and 60 arcminutes make up one degree. A full circle around you is 360 degrees, so there are 1,296,000 arcseconds in a full circle.

A large quantity of unused protoplanetary material called the Main Asteroid Belt is found in a torus-shaped ring primarily constrained between the orbits of Mars and Jupiter. Its most significant fragment is an object called Ceres – once considered to be an asteroid, it is now labelled a dwarf planet. Beyond the orbit of Neptune lies the Kuiper Belt, where many small worlds reside. The former planet Pluto (now labelled a dwarf planet) spends most of its orbit in the Kuiper Belt. Astronomers theorise that thousands of worlds could be lurking in this remote region, which extends to approximately 50 AU from the Sun (the upper limit of Pluto's orbit). All things considered, the Kuiper Belt and everything inside it is just a tiny bubble at the centre of our Solar System. Beyond this region is a much larger swarm of small icy bodies comprising the Scattered Disc. It is much less flat than the planetary region, and extends to a distance of perhaps 1000 AU – more than 30x the distance to Neptune. At this scale, the Solar System seems to be

truly enormous, but if we define the Solar System as all the objects bound to and influenced by the Sun, we are still nowhere near the edge. Beyond the Scattered Disc is the Oort Cloud – the hypothetical source of long-period comets. It is thought that many trillions of icy fragments drift around here, having formed among the outer planets before being thrown out to extremely great distances by their gravity. Computer models suggest that the most distant members of the Oort Cloud are as much as 100,000 AU from the Sun, which corresponds to 1.5 light-years! The full diameter of our Solar System, then, would be around 3 light-years – comparable to the space between stars. The Sun exerts gravitational influence into the interstellar region around it. At this scale, the Sun and planets inhabit an almost infinitesimally small point in the centre of the Solar System.

Remarkably, despite occupying such a small volume of the Solar System, the Sun retains 99.8% of its mass. All the planets, asteroids, comets and undiscovered worlds in the uncharted regions beyond Neptune collectively make up the remaining 0.2%. Furthermore, every single object in the Solar System could fit inside the Sun with

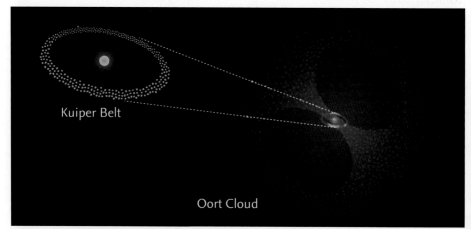

The Kuiper Belt, Scattered Disc and Oort Cloud are far larger than the planetary system, which occupies a relatively small region comparatively close to the Sun.

UNDERSTANDING THE SOLAR SYSTEM

room to spare. Spread apart, they occupy an enormous volume. But all of these objects are, on average, extremely distant from one another relative to their sizes. The Solar System is mostly empty space. Fortunately for us, the Sun's intense radiance is bright enough to illuminate its many worlds for us, bringing a few to naked-eye brightness, and many more within reach of an amateur telescope.

Motion

The overall motion of the Solar System has been inherited from its formation, with the angular momentum of the presolar nebula determining its rotation. All the planets and minor planets orbit the Sun in the same direction, which is anticlockwise as observed from over the north pole of the Sun. In a similar fashion, most of the planets rotate anticlockwise as observed from over their north poles. The exceptions are Venus, which rotates in the opposite direction, and Uranus, which is toppled with an axial tilt of 98 degrees – virtually on its side with respect to the plane of the Solar System. Astronomers think Venus may also have been toppled due to an impact or an interaction with an extinct planetesimal early in its history, and that it is technically upside down with an axial tilt of 177 degrees. Alternatively, it started life with prograde rotation, gradually slowed, and finally reversed due to tidal interactions with the Sun. Uranus could have been struck by an Earth-sized planetesimal, or interacted with Neptune in a manner that changed its axis of rotation.

Most of the Solar System's major moons orbit in the same direction as the rotation of their parent planet. The exception is Neptune's large moon Triton, which may have been captured from the Kuiper Belt. However, there are a significant number of small irregular moons with retrograde orbits – they travel around in the opposite direction to the planet's rotation. Most of the moons of Jupiter, for example, are in retrograde orbits, having likely been gravitationally ensnared from the asteroid belt.

The apparent motion of the Solar System is more complex than its true motion. We can imagine its appearance from a great distance, but on Earth we are compelled to view it from a moving stage – an ever-changing perspective. We see the Sun traverse the ecliptic once per 365.25 days. The Moon and planets also appear close to the ecliptic, as do the brighter asteroids. Comets, which may have highly inclined orbits, can move into regions of the northern and southern celestial hemisphere that the planets cannot. As we move around the Sun, we are routinely overtaken by the faster-moving planets – Mercury and Venus – which trace figure-8 paths to the east and west of the Sun. They pass behind the Sun (superior conjunction) and travel towards the east for an evening apparition. They then move west again towards the Sun, passing in front of it (inferior conjunction) to 'swing out' toward the west for a morning apparition. The cycle completes when they move eastward behind the Sun again. The slower-moving planets – from Mars outwards – begin their apportions west of the Sun during the mornings before dawn, and gradually rise earlier as we move around to come between them and the Sun. As we overtake them, they are said to be at opposition (opposite the Sun) and can be seen through the night, appearing at their largest and brightest for that apparition. After opposition, they rise before sunset and eventually appear due west, following the Sun below the horizon. It is our motion that creates this perspective, and as we all move together, at times the planets appear to stand still for a few nights (relative to the stars) or even drift backwards with apparent retrograde motion. These curiosities in the motions of the planets are interesting to watch, and thankfully are not detrimental to our planning or observations.

3: PLANNING YOUR OBSERVATIONS

Before we look at astronomical hardware, including telescopes and eyepieces, it will be useful to introduce tools that enable us to predict the positions of Solar System objects in the sky. Because they're in constant motion, their visibility and appearance are time-dependent. Fortunately, there are many excellent resources available online at no cost, which you can use to plan your observations as thoroughly as you like.

Theory and Background

The stars and other deep-sky objects are positioned on the celestial sphere using two coordinates – right ascension (RA) and declination (Dec). These are equivalent to longitude and latitude over the Earth's surface. For an observer on the ground, the apparent position of anything in the sky is given by a separate set of coordinates: altitude and azimuth. Altitude is measured from the local horizon (0°) to the zenith immediately overhead (90°). Azimuth is a bearing measured from north (0°) through east (90°), south (180°) and west (270°). The altitude and azimuth of everything in the sky continually changes due to the rotation of Earth, but Solar System objects also change position on the celestial sphere. Thus, their right ascension and declination is also in constant flux as a result of both their own motion around the Sun and the motion of the Earth. Naturally, objects that are close to us, like the Moon, and objects that are close to the Sun, like the terrestrial planets, show relatively rapid changes in their positions. However, the Earth's rotation plays a much larger role in where they will appear from one hour to the next. The Moon generally shows the fastest apparent motion of any natural object relative to the stars, drifting approximately one lunar diameter (0.6°) eastward per hour, but the constellation hosting it is displaced westward by 15° per hour. Solar System objects are constantly changing in right ascension, declination, altitude and azimuth.

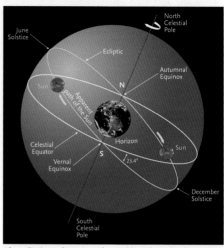

The ecliptic path projected onto the celestial sphere. It is inclined to the celestial equator.

Coordinates for Solar System objects are given in two frames of reference. The difference is subtle but important. Geocentric coordinates are calculated with respect to the centre of the Earth. This point is mathematically significant for Solar System calculations, such as the exact distances between two bodies, but because we are (hopefully) not at the centre of the Earth, objects that are comparatively close to us will appear displaced from their geocentric coordinates. We must instead calculate topocentric coordinates, which are specific to a particular location on the Earth's surface. From pole to pole, the Earth measures nearly 8,000 miles (12,700 km) so two observers at very different latitudes will view the Moon and nearby planets from slightly different angles. The resulting parallax can be the difference between an occultation being visible, the appearance of an eclipse, or the splendour of a lunar-planetary conjunction. For remote planets, the parallax is far smaller.

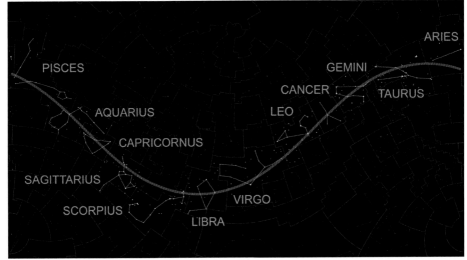

The ecliptic (shown in yellow) intersects the constellations of the zodiac.

We have seen that the Earth's orbit defines an apparent path for the Sun – the ecliptic – which traverses the zodiacal constellations by definition. The Solar System is not perfectly flat, but neither is it far from it. The orbits of the planets and minor planets are for the most part only slightly inclined to one another, so that from our perspective they do not stray far to the north or south of the ecliptic. Likewise, the Moon's orbit is inclined, but it too appears close to the ecliptic. As a result, we can enjoy frequent eclipses and conjunctions, and the Solar System can be seen from everywhere on Earth. Due to the axial tilt of the Earth, the ecliptic is inclined to the celestial equator by 23.4°. This is known as the *obliquity of the ecliptic.* As such, the northern and southern hemispheres see different zodiacal constellations at different altitudes, and so seasonal variations in the positions of Solar System objects affect their visibility. For example, the constellations Gemini and Taurus are at the northernmost extreme of the ecliptic, and they are best seen in the northern hemisphere during the winter months. Therefore, if a planet is situated in one of these constellations during the winter, it is well-placed, due south for observers at northern latitudes. By contrast, these constellations appear low in the north from southern latitudes during the local summer. Therefore, southern observers will have a diminished view of that same planet, relatively low over their northern horizon. As we'll see, this variability informs the way we approach observing with telescopes. Comets are commonly seen outside the zodiacal band, as their highly inclined orbits take them from one hemisphere to the other, and we will cover their forecasting in more detail in a dedicated chapter.

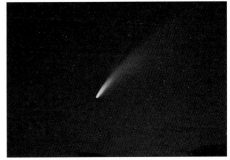

Comets can have highly inclined orbits, and can appear far from the ecliptic in the sky.

Orbits in two-body systems, which are reasonable approximations of the

planets, can be characterised using six numbers, termed orbital elements. For the planets and other well-studied objects, these elements and various qualifying perturbations are tightly constrained, but for newly discovered objects like comets, the elements can change, sometimes significantly, as further observations are made to refine our understanding of the orbit and constrain errors. The accuracy of the elements determines how well we can predict the future position of a celestial body, and thus calculations should always be made with the most up-to-date elements. It would be an exhausting task to make such calculations manually, so it's fortunate that we live at a time when freely available, home planetarium software can download orbital elements and plot predictions automatically.

Useful Software for Planning Observations

Using software, we can circumvent complex calculations and plot the appearance of the sky visually. For any given time and date at any location, the position, apparent size and brightness of an object can be simulated. You can find links to all the software mentioned in this guide in the resources section at the end of the book. Further software specifically used for imaging will be introduced in Section 7.

STELLARIUM
The world's most popular planetarium software is Stellarium – a free, open source, multi-platform application that accurately visualises the sky. It's extremely useful for all forms of visual astronomy, but of particular interest to us is its versatile suite of plugins tailored for Solar System observers. Stellarium can be installed on a home computer, mobile device or tablet, or used as a web app in a browser. The desktop version is recommended, as it is the most fully featured. You should download Stellarium and familiarise yourself with its features. When selecting an object, pay attention to the data that appears on the left side of the screen. It includes the magnitude (apparent brightness), angular diameter and transit time, as well as the elongation, which is particularly important for determining when Mercury and Venus are at their most favourable. You can advance the time and date into the future in order to predict when to carry out your observations.

Stellarium includes a sophisticated ocular view tool, which will simulate the appearance of a planet through your telescope. You will need to enter the details of your telescope and eyepieces, after which it will calculate the magnification and render the field of view. Note that the apparent field of view in a real eyepiece will seem larger than it appears on your computer screen. Alongside the ocular view tool is the imagine field simulator. This tool will show you the angular size and resolution of an image for any given camera sensor, telescope and image amplifier. We will refer to this again in Section 7. As with the ocular tool, you will need to enter data yourself to get the most out of it, but it is trivial to do so, and Stellarium will save the details of your instruments for quick access in the future.

VIRTUAL MOON ATLAS
The Virtual Moon Atlas for Windows is a programme that plots the appearance of the

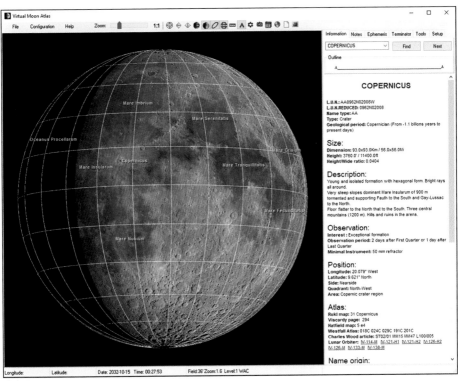

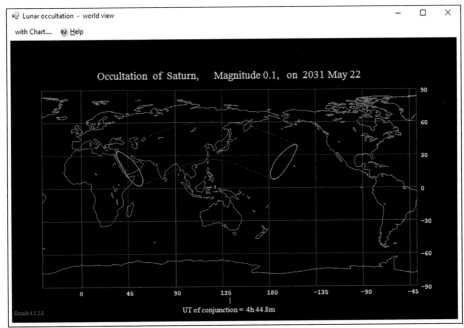

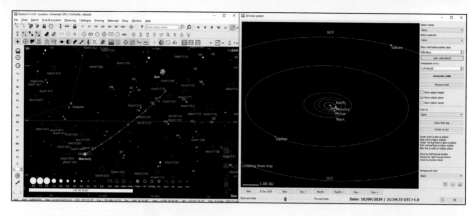

Moon, and labels features. It is a feature-rich tool for serious study of the Moon, but also perfect for beginners planning to view its surface with small telescopes. The programme allows you to search for the name of any feature on the Moon and see its position. It also accurately simulates lunar libration – an apparent 'wobbling' of the Moon caused by its elliptical and inclined orbit, which allows us to see more of one edge or the other throughout the lunar month. At the time of publication, Virtual Moon Atlas is not distributed for MacOS, but it can be emulated using WINE on Apple computers.

OCCULT

The Occult programme, written by David Herald, is endorsed by the International Occultation Time Association (IOTA) for calculating and predicting a wide range of occultations, which are discussed later in this book. These include events in which the Moon passes in front of a planet, as well as lunar and solar eclipses. Occult is available for Windows and is free, but if you cannot run it, you will be able to find the information using websites and apps, some of which are detailed in the next chapter.

SKYTECHX

Written and maintained by Pavel Mráz, SkytechX is a sophisticated free planetarium application for Windows that offers excellent tools for Solar System observers, including the ability to plot the paths of planets, asteroids and comets over time. You can

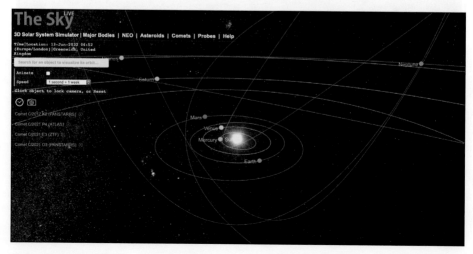

use this software to visualise the location of an object over a range of dates, and render the track onto a single star chart for future reference. SkytechX also offers a 3D Solar System visualisation, and a fully-featured Moon globe with additional high-resolution textures that are available as a separate download. The software is similar to Stellarium, and whilst not available on a wide range of operating systems, it is more useful for producing charts.

Online Resources

The following web-based tools are worth bookmarking for any Solar System observer. Websites are particularly useful for obtaining up-to-date information including recently discovered comets and calculations that become more accurate over time.

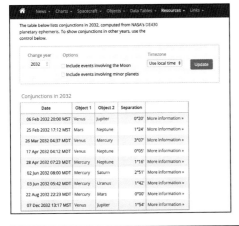

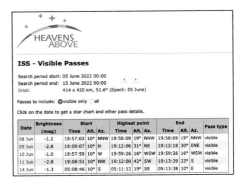

THESKYLIVE | THESKYLIVE.COM

With a wide variety of up-to-date information, and the capacity to plot the position of Solar System objects on a chart, TheSkyLive is an excellent resource. Its planetarium page, similar to Stellarium, allows you to look up any object in the sky and plot its visibility for any location, date and time. Meanwhile, the comets page provides a gallery of over 200 comets in order of apparent brightness. The 3D Solar System display provides context for the relative locations of Solar System objects, including notable comets whose orbits have brought them closer to the Sun than Jupiter.

IN-THE-SKY | IN-THE-SKY.ORG

A website providing a great deal of data about the night sky. It can generate charts, show the positions of objects including satellites, and most notably produce a list of upcoming conjunctions of the planets, including those with the Moon and minor planets. The conjunctions tool is found under Resources >

Moon Phases for London, England, United Kingdom in 2027									
Lunation	New Moon		First Quarter		Full Moon		Third Quarter		Duration
1287	7 Jan	20:24	15 Jan	20:34	22 Jan	12:17	29 Jan	10:55	29d 19h 32m
1288	6 Feb	15:56	14 Feb	07:58	20 Feb	23:23	28 Feb	05:16	29d 17h 33m
1289	8 Mar	09:29	15 Mar	16:25	22 Mar	10:43	30 Mar	01:53	29d 14h 22m
1290	7 Apr	00:51	13 Apr	23:56	20 Apr	23:27	28 Apr	21:17	29d 11h 07m
1291	6 May	11:58	13 May	05:43	20 May	11:59	28 May	14:57	29d 8h 42m
1292	4 Jun	20:40	11 Jun	11:56	19 Jun	01:44	27 Jun	05:54	29d 7h 22m
1293	4 Jul	04:02	10 Jul	19:39	18 Jul	16:44	26 Jul	17:54	29d 7h 03m
1294	2 Aug	11:05	9 Aug	05:54	17 Aug	08:28	25 Aug	03:27	29d 7h 36m
1295	31 Aug	18:41	7 Sep	19:31	16 Sep	00:03	23 Sep	11:20	29d 8h 55m
1296	30 Sep	03:36	7 Oct	12:47	15 Oct	14:47	22 Oct	18:29	29d 11h 00m
1297	29 Oct	14:36	6 Nov	07:59	14 Nov	03:25	21 Nov	00:48	29d 13h 48m
1298	28 Nov	03:24	6 Dec	05:22	13 Dec	16:08	20 Dec	09:10	29d 16h 48m
1299	27 Dec	20:12							29d 19h 00m

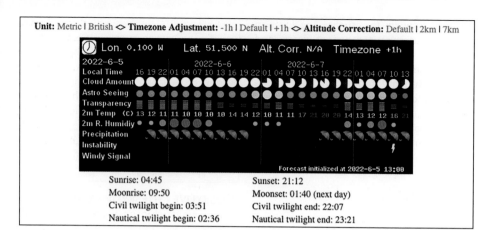

Sunrise: 04:45	Sunset: 21:12
Moonrise: 09:50	Moonset: 01:40 (next day)
Civil twilight begin: 03:51	Civil twilight end: 22:07
Nautical twilight begin: 02:36	Nautical twilight end: 23:21

Articles, by clicking on the word conjunction in the alphabetical index.

HEAVENS ABOVE | HEAVENS-ABOVE.COM

This site is a superb resource for satellite chasers, allowing you to calculate when spacecraft such as the International Space Station will be visible in your skies. It can also generate data about natural objects in our Solar System. Like many other tools listed here, it will require your general location to be entered.

TIME AND DATE | TIMEANDDATE.COM

This easy to use website hosts a wealth of information about the Sun and Moon, providing their rising and setting times, the Moon's phases, and comprehensive eclipse information for anywhere on Earth. The eclipse calculator can simulate the appearance of the Moon and Sun during lunar and solar eclipses, and show their coverage across the world's surface. Time and Date also lists major upcoming meteor showers, with charts showing the position of the radiant for each in the sky.

7TIMER! | 7TIMER.INFO

The 7Timer! website provides worldwide weather forecasts, which contain data of special interest to observers. After selecting your location, choose ASTRO to generate a 72-hour forecast that includes both 'seeing'

and transparency, which are discussed in Section 4. Good seeing, represented by a smaller, dark blue point, is particularly

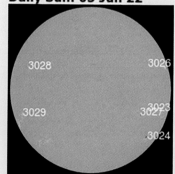

Solar wind
speed: **274.4** km/sec
density: **14.04** protons/cm^3
more data: ACE, DSCOVR
Updated: Today at 0927 UT

X-ray Solar Flares
6-hr max: **B7** 1530 UT Jun05
24-hr: **C1** 1225 UT Jun05
explanation | more data
Updated: Today at: 2130 UT

Daily Sun: 05 Jun 22

3028 3026

3029 3023
 3027
 .3024

Expand: labels | no labels
New sunspots AR3028 and AR3029 have stable magnetic fields that pose no threat for strong solar flares. Credit: SDO/HMI

important for viewing the Moon and planets with a telescope. Better transparency will also allow more detail to be seen, and is indicated by a small number of blue horizontal bars. 7Timer! is worth checking alongside your usual weather information service, and will allow you to target times that allow you to use higher magnifications, particularly for the first upcoming night.

SPACEWEATHER | SPACEWEATHER.COM
Contrary to the name, this website has nothing to do with the weather. Rather, it provides a daily update on the space weather environment, which is usually most pertinent for aurora chasers. However, the SpaceWeather homepage also contains a labelled image of the Sun's face, including visible active regions and sunspots. In Section 5, we'll explore how to safely observe the Sun either indirectly or with a filtered telescope.

4: ASTRONOMICAL OPTICS

Our understanding of the Solar System was made possible by the invention of the telescope – an instrument that has become ubiquitous, with good options available at almost any budget. In the following chapters, we'll explore telescope designs and accessories that are ideally suited for the targets in this guide. If you already own a telescope, the advice on the following pages will help you squeeze the most performance out of it. Before that, let's briefly look at the Solar System with the unaided eye and binoculars.

Limits of the Human Eye

Our eyes are superb instruments, but it's not controversial to say that they are generally unsuitable for exploring the Solar System. This is hardly surprising, as at no point in our evolution has it been necessary to see what is happening on Mars! To our eyes, the Moon and the Sun are the only Solar

System objects resolvable as discs. Beyond this, five planets are visible as mere points of light. The only other natural objects which are readily visible to the unaided eye are bright comets and pieces of cometary debris striking our atmosphere in the form of meteors. This leaves some artificial objects, such as satellites, but most of the objects in our Solar System, and certainly all their hidden details, are forever out of reach without some optical aid.

This doesn't mean we can't enjoy the Solar System by eye. Indeed, some things we will discuss towards the end of the book are best enjoyed *without* binoculars or telescopes. Meanwhile, the Moon and naked-eye planets are a fine sight. The Moon's phases, largest features and earthshine can be appreciated by eye, whilst Mercury, Venus, Mars, Jupiter and Saturn appear to us as bright, steady stars.

It is possible to observe the Sun by eye, but you should never look at it directly without using a dedicated solar filter. The filter material discussed on pages 60–61 can be used for safe solar viewing. Generally, it will be difficult to see any features on the Sun with the unaided eye. Very large sunspots or sunspot groups can be resolved, but such occurrences are rare. It is also possible to view transits of Mercury and Venus, which are explained towards the end of this book, but in all cases it is better to view the Sun via projection or a filtered telescope to enjoy these events.

The key limitations of the eye are resolution and magnification. A fully dark-adapted pupil, which may be dilated up to 8 mm in diameter, is a small aperture when compared to even a modest telescope. Resolution is dependent on aperture diameter, and can be approximated using the formula first given by William Rutter Dawes in 1866.

$$R = \frac{116}{D}$$

When adjusted to the dark, the eye's pupil dilates to as much as 8 mm in diameter. The maximum dilation declines with age.

Where R is the resolving limit in seconds of arc (arcseconds) and D is the instrument diameter in mm. The resolving limit is a measure of the minimum angular separation between two resolvable sources or features (such as a pair of stars or the edges of a lunar crater). The larger the aperture, the smaller R becomes, and thus smaller features can be seen. As we'll see, this is not the only factor in determining resolution, but it is applicable at most practical magnifications. Unfortunately, the unaided eye can't alter its magnification; we simply see the world from a fixed, wide-angle perspective. In theory, a fully dilated pupil can resolve 14.5 arcseconds, enough to see Jupiter's Galilean moons flanking the planet's disc, but without the ability to zoom in, such fine details fall below our visual perception threshold. Binoculars and telescopes are designed to compensate for lack of resolving power and magnification.

Binoculars

A pair of binoculars is an excellent tool for getting started in astronomy. Typically, binoculars range in aperture from 40 mm to 80 mm, with 50 mm and larger being considered most suitable for sky-watching. Magnifications usually range from 6× up to 25×. Galileo's first useful telescope offered just 9× magnification, so most binoculars on the market today – even affordable options – will outperform the tools that first unlocked the Solar System.

A pair of 10×50 binoculars.

10×50 binoculars (10× magnification with 50 mm front lenses) are very popular among stargazers, as they offer a good balance of power and portability. With binoculars of this size, you can readily make out large features on the Moon, including several prominent impact craters and the ray systems that surround them. Binoculars also reveal the Ice Giants, which are too faint to detect by eye (except Uranus in exceptional conditions). This means that a pair of binoculars can show you every planet in the Solar System, and in some cases can reveal their discs. With a resolving power of 11.6 arcseconds, the phases of Venus are easily seen in 10×50 binoculars, as is the disc of Jupiter and its four largest satellites, the Galilean Moons. Mars, Mercury and Saturn are more challenging. Around

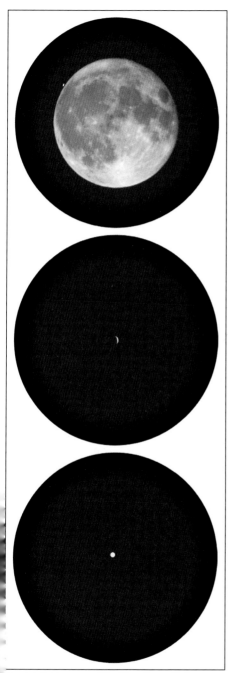

Simulated appearance of the Moon, Venus (during a crescent phase) and Jupiter (with the Galilean Moons) through a pair of 10×50 binoculars.

opposition, the disc of Mars can be seen, as can some of Mercury's phases. Saturn's rings aren't clearly resolved in binoculars, but the planet does show an elongated shape. Uranus and Neptune at their remote distances appear as faintly green and blue points of light, respectively.

With a limiting magnitude of +9.5, 10×50 binoculars can also reveal more than a dozen objects in the asteroid belt, including the dwarf planet Ceres, and numerous periodic comets that do not reach naked-eye visibility. True to their name, meaning 'star like', asteroids appear merely as stars at all practical magnifications, but comets appear 'non stellar'. Bright comets, meanwhile, make very fine sights through binoculars, with their bright nuclei and long, diffuse tails stretching across several degrees of sky. 10×50 binoculars usually provide a true field of view of around 6.5 degrees, a little over ten times the width of the Full Moon. As a rule of thumb, lower magnifications will show a wider region of sky, whereas high magnifications will show a narrow region. However, some binoculars boast a wide apparent field of view at the eye lens, and it is possible for 10×50 binoculars to show 8 degrees of sky. These designs are more expensive to manufacture and naturally more expensive to buy. For Solar System observers, they offer little benefit over a traditional, less expensive pair.

Holding binoculars for anything other than a short period of time will lead to fatigue and make it harder to enjoy the view, so consider using a tripod and binocular mount to make viewing easier. You'll need a tripod that extends to a good height – taller than yourself, so you can look upwards while standing.

If you're new to binoculars, take some time to familiarise yourself with the dioptre adjustment. Your eyes focus at slightly different distances, and the dioptre will

compensate for this to eliminate eye strain. Be sure to set the inter-pupillary distance until the field of view appears circular. Contrary to what we are often shown in the media, binoculars should not produce a double-lobed image!

Telescope Designs

The telescope is the ultimate tool for exploring the sky. Purpose built and highly adaptable with thousands of accessories, it can take you to other worlds and far beyond. Throughout history, numerous telescope designs have been introduced, each with their strengths and weaknesses. Strictly speaking, there is no popular design that can be called unsuitable for Solar System observation, but some will outperform others. All the popular designs on the market today fall into one of three categories: refractors – telescopes that use a main lens to focus light through refraction; reflectors – mirror-based telescopes that are inexpensive to manufacture; compound or catadioptric – combination designs that rely on lenses and mirrors for compactness.

The mount and tripod, and other accessories can also be considered part of the overall telescope system, but first we will evaluate the optical tube assemblies. As a general rule, larger apertures provide clearer views, particularly at high

Powerful, high-quality telescopes have become ubiquitous and affordable, offering superb views of the Solar System in close-up.

magnification, but the best telescope is ultimately the one you use the most. A smaller, less bulky instrument that is easier to set up will ultimately provide a better observing experience than something too cumbersome to bother with!

REFRACTORS

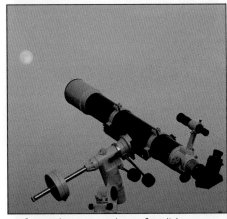

A refractor telescope uses a lens to focus light.

Refracting telescopes rely solely on lenses to focus light. At the front of the telescope is the objective lens. They are the descendants of the earliest telescope concept, as developed by Galileo and Kepler in the early 17th Century, but modern refractors are far better at forming sharp, high-contrast images today. Refracting objective lenses are composed of at least two elements, each made from different kinds of complementary glass. In some cases, three or more elements are used to achieve better colour correction. False colour, or chromatic aberration, is a design drawback of refracting systems. Light passing through a lens will be dispersed such that its component colours don't reach a common focus. As a result, we see 'fringing' – usually blue or green – around bright edges. The dispersion of colour also affects the visibility of features that show colour contrast, such as the storms in Jupiter's upper atmosphere. Early refractors suffered a great deal of false colour, but

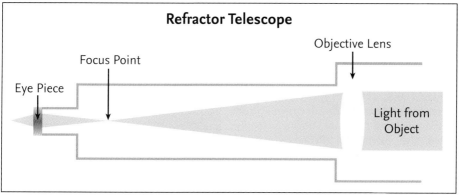

Refractor Telescope

Objective Lens

Focus Point

Eye Piece

Light from Object

Diagram of a refracting optical system.

today's inexpensive 'achromatic' refractors fare much better. Expensive designs, which use additional lens elements or premium glass to further reduce false colour may sometimes be termed 'apochromatic'. There is no strict definition for this term, and it's often used in marketing, so beware of so-called APOs sold at premium prices, which might not be substantially better than their budget counterparts.

False colour is also less prevalent at high focal ratios. The focal ratio (f) of an objective lens (or mirror) is given by the formula:

$$f = \frac{F_t}{D}$$

Where F_t is the focal length of the telescope – the distance between the objective lens or mirror and the focus point (or focal plane) – and D is the diameter of the objective lens or mirror, both given in the same units. For example, a telescope with a 1000 mm focal length and a 100 mm wide objective lens will have a focal ratio of 10, denoted f/10. Focal ratios of about f/7 or higher are considered optically 'slow' whereas f/6 or lower is 'fast'. These terms relate principally to photography, and the focal ratio is particularly important when selecting an astrograph for deep-sky astrophotography. For Solar System observation, the focal ratio is less crucial, but achromatic refractors

with fast focal ratios should generally be avoided, as they will show a great deal of false colour unless stopped down (limiting their resolving power in the process).

A refractor by its design is not folded in any way. Light is focused inside the tube to be received at the eyepiece end. A refractor with a long focal length will therefore necessarily be physically long and thus not very compact. A short-tube apochromatic refractor can produce similar or better views, provided it is well-corrected, in a portable package. However, as we will see, some additional costs may need to be covered to achieve high-magnification views.

Refractors are robust and require little maintenance. They are relatively expensive per mm of aperture, but large apertures are not necessarily required. Refractors also benefit from a fully clear aperture. Reflecting and compound designs require an obstruction at the front of the telescope, which disturbs incoming light and reduces contrast. Refractors have unobstructed apertures, and provide exceptionally good contrast, which is particularly advantageous for viewing planetary features, like Jupiter's Great Red Spot or the polar ice caps of Mars.

Refractors produce images that are inverted and mirrored, meaning that

they are essentially rotated 180 degrees. A star-diagonal, commonly used at the back of the telescope to hold the eyepiece at a comfortable angle, will flip the image upright but leave it mirrored left to right.

REFLECTORS

Isaac Newton is credited with the invention of the reflecting telescope, now commonly called the Newtonian Reflector in his honour. Reflectors rely on mirror assemblies, rather than lenses, to focus light. They don't suffer from chromatic aberration, as light is not dispersed when it is reflected, and they are the most cost-effective to manufacture. Reflector main mirrors are made of borosilicate glass, ground and polished into a near-perfect spherical or parabolic section. This is then 'silvered' – treated with highly reflective coatings – and placed at the back of the telescope tube. Light enters the tube and is reflected forward, where it is intercepted by a secondary mirror mounted on thin struts inside the tube. This flat mirror reflects the light at a 90-degree angle, sending it out through the side of the tube where the focuser and eyepiece are situated. Newtonian telescopes produce images that are inverted and mirrored.

Newtonian telescopes are physically shorter than their focal length, as the light path is partially folded by the secondary mirror. Owing to their inexpensive design, for any

A Newtonian reflector telescope uses a mirror to focus light.

given budget, you can generally buy a larger reflector and comparatively priced refractor. This makes them a popular choice for deep-sky observers, who crave the extra light grasp to reveal faint objects, but a larger aperture also offers greater resolving power.

Newtonian reflector telescopes generally require more maintenance than any other design. The primary mirror is mounted on a cell that is designed to be adjusted using a set of screws. This process is called collimation, and it is necessary to create good images. Collimation ensures that the mirrors are perfectly 'on axis' with one another, and incoming light rays follow the correct optical path. When the telescope is moved, stored, or set up, the mirror cell will change

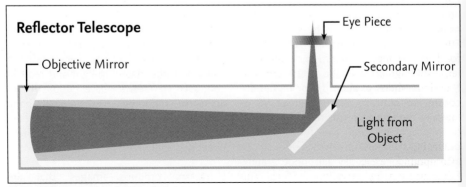

Reflector Telescope

Eye Piece

Objective Mirror

Secondary Mirror

Light from Object

Diagram of a Newtonian reflector optical system.

position slightly, and so regular collimation is required. Without proper collimation, images will always appear somewhat soft, as if out of focus, and point sources (such as moons) will show an aberration called coma. Coma can never be fully eliminated from a Newtonian reflector – it is always present near the edge of the field where incoming rays are reflected by the highly curved edges of the mirror. However, a well-collimated reflector will have a 'sweet spot' around the centre of the field, which is free of coma.

One other drawback of the Newtonian design (and common among all reflectors) is the position of the secondary mirror. Situated at the front of the tube, it creates a central obstruction in the telescope aperture. It's usually supported by four thin struts. Incoming light is perturbed by the obstruction as it diffracts around it, and this causes it to be dispersed. Consider the venerable Hubble Space Telescope, which uses a Ritchey–Chrétien optical design. This is also a reflector, with a secondary mirror mounted on four struts. Every bright source, such as a brilliant star, appears to have cross-shaped spikes coming out of it. Some of the starlight is being spread into this false pattern, reducing the contrast of the image.

Planets are not point sources, and Newtonian reflectors will not endow them with diffraction spikes, but the secondary mirror does spread their light and reduce their contrast. When comparing views in small refractors and reflectors, those in the former tend to appear more vibrant, with darker blacks. The deep shadows and brilliant highlights of the Moon are more striking, whereas colourful features appear more saturated. In contrast, the reflector images are slightly 'washed out'.

COMPOUND (CATADIOPTRIC)
Compound telescopes are reflectors, but they also employ lenses in a folded design that favours compactness. The two more

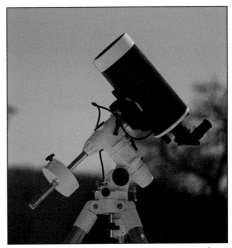

A compound telescope uses mirrors and lenses to focus and correct an image.

popular types of compound telescope are the Schmidt–Cassegrain Telescope (SCT) and Maksutov–Cassegrain Telescope (MCT or Mak). As the names imply, these are variations of the Cassegrain design, which uses a parabolic primary mirror and hyperbolic secondary mirror. The secondary mirror sends the incoming light back down the tube and through a hole in the primary mirror to form an image at the back. The focal length is folded to fit a long telescope into a short tube.

The Schmidt–Cassegrain design uses a flat corrector plate and two spherical mirrors, making it simple to manufacture with good precision. It typically has a native focal ratio of f/10, and can be used in conjunction with focal reducers or extenders (such as Barlow lenses) to perform well on a wide variety of targets. The corrector plate also houses the secondary mirror, so there are no struts to produce diffraction spikes. However, the mirror is a large obstruction and SCTs suffer from reduced contrast in much the same way as Newtonian reflectors.

The Maksutov–Cassegrain design uses a spherical meniscus lens with a secondary

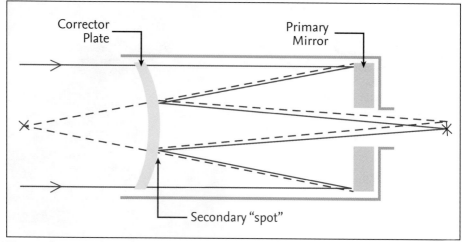

Diagram of a compound optical system.

mirror 'spot' bonded to the inside surface. The lens provides a complementary symmetry to the mirror assembly and eliminates coma and chromatic aberration simultaneously. MCT optical tube assemblies usually have native focal ratios of f/12 or higher, making them extremely compact for their long focal lengths. The obstruction ratio of the secondary mirror is smaller than a Newtonian or SCT, minimising its impact on the contrast of the image. MCTs are often lauded for their 'refractor-like' views, and they're popular among dedicated Solar System observers.

Both SCT and MCT telescopes form images which are inverted and mirrored, and like refractors they are typically used with star diagonals for comfortable viewing. The resulting images appear upright but mirrored.

MOUNTS
Telescope mountings fall into two categories: altitude over azimuth (AltAz) and equatorial (EQ). AltAz mounts pivot on the altitude and azimuth axes, much like a pan-tilt tripod head. Equatorial mounts also pivot on two axes, but they are tilted and aligned with the Earth's polar axis. As a result, they follow

the coordinate lines of the celestial sphere, right ascension and declination. Because the equatorial mount revolves around the polar axis, it can counteract the rotation of the Earth using a single-axis motor or clock drive, which moves at a rate equal to the sidereal rotation rate of the Earth – one revolution every 23 hours and 56 minutes. An AltAz mount will require two-axis tracking to remain pointed at a given object, and the field seen in the eyepiece will gradually rotate.

For an equatorial mount to perform accurately, it must first be aligned to the polar axis. This polar alignment involves sighting the north or south celestial pole through the axis using a polarscope. The telescope must then be balanced using counterweights so that it can rotate smoothly about the polar axis without putting strain on the mount. When properly set up, this is an elegant system, but you should be aware of the additional time required, the complexity and weight of an equatorial mount before investing in one.

In contrast, the AltAz mount is much simpler and usually lighter, at the cost of accuracy. However, there are many excellent

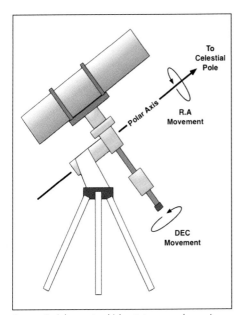

An equatorial mount, which rotates around an axis aligned to the Earth's polar axis.

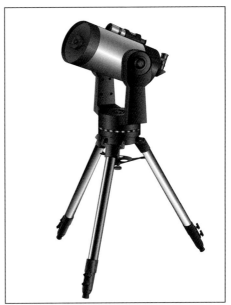

A computerised Alt-Az mount, capable of finding and tracking objects in the sky.

computerised AltAz mounts available today that will find and track objects in the sky with little error. In some cases, they can even set themselves up automatically. The ability to track the sky, be it manually with smooth slow-motion controls, or automatically with precise motors, is extremely valuable to Solar System observers. We usually magnify our images by some hundreds of times, zooming right in on small areas of the sky. Without tracking, the Earth's rotation will carry us and our telescopes around and away from our target, causing the object to move out of the field of view quickly.

To illustrate this, let's look at an example at high magnification. The true field of view at the eyepiece is given by:

$$TFoV = \frac{AFoV}{Magnification}$$

Where TFoV is the true field of view, and AFoV is the apparent field of view through the eyepiece. Consider a fairly typical eyepiece with a field of view of 50 degrees.

At a magnification of 150×, it delivers a true field of view of 0.33 degrees, or 20 arcminutes. The drift rate of the sky due to the Earth's rotation is 0.25 degrees per minute, or 15 arcminutes per minute. Therefore, at 150× magnification, if we set a planet at the edge of the field, it will take 0.75 minutes or 45 seconds to reach the opposite edge. This is assuming the planet is placed at the easternmost edge of the field. From any other part of the field it will take even less time to leave. The centre of the eyepiece field is more comfortable to view, and in most cases provides a better image, so in practice we'd need to reposition our telescope every 20 seconds or so. At higher magnifications, the problem is exacerbated.

You can certainly enjoy the Solar System without a tracking telescope, particularly at low magnifications, but if you are in the market for a telescope or mount, it's a feature worth considering within your budget.

A 90-degree star diagonal.

A 45-degree erecting prism for terrestrial viewing.

Telescope Accessories

The Optical Tube Assembly (OTA) is one part of the telescope's optical system. It collects and focuses light, forming an image. It is what we do with this image that determines our view. We can use a variety of accessories to reflect, magnify and filter the image depending upon our goals. The amateur astronomy industry has adopted two standard focuser and accessory sizes: 1.25″ (31.7 mm) and 2″ (50.8 mm). If you have a 2″ focuser, you can always step it down to the smaller format, and most telescopes designed for 2″ accessories will include the necessary adapter.

STAR DIAGONALS
Refractor and compound telescopes can be used either straight through or with a star diagonal – a mirror assembly that reflects the image by 90 degrees. Inserting the eyepiece directly into these telescopes will entail viewing by looking upwards and unless the telescope is mounted very high, or you have a very well-positioned chair with good neck support, it will be uncomfortable. A star diagonal is not only more comfortable, it also provides extra path length for the telescope. For refractors, this means less focuser travel is required.

Alongside star diagonals, some manufacturers offer erecting prisms, which correct the image for terrestrial viewing, at either 45 degrees or 90 degrees. They are worthwhile if you'd like to use your refractor or compound telescope as a spotting scope, but they should be avoided for astronomical use. These prisms contain glass which will introduce aberrations such as false colour, and usually soften the image. This slight reduction in image quality is tolerable when bird spotting, or watching ships out at sea, but it has a much more noticeable impact on astronomical targets, which show very fine details and high-contrast edges.

EYEPIECES
Magnification of telescope images is performed by the eyepiece, which samples a portion of the field and enlarges it. At the front of the eyepiece is the field lens, which is analogous to the objective lens of a refractor telescope. However, eyepieces do not focus light, but rather spread it out, such that the image sample appears larger to the eye. This spreading of light is the essence of image magnification. The larger 2″ eyepiece format can accommodate a larger field lens, which is excellent for achieving wide-angle, low magnification views. For Solar System work, this is almost never necessary, as we are concerned with sampling a small region of the field.

A Barlow lens (left) and telescope eyepieces of different focal lengths.

To determine the magnification factor of any given eyepiece, you need to know its focal length. This is a measure of the required distance between the telescope focal plane and the eyepiece field lens, in order for the eyepiece to make incoming light parallel, and it will be given in mm on the side of the eyepiece itself. Magnification, M, is given by a simple formula.

$$M = \frac{F_t}{F_e}$$

Where F_t is the focal length of the telescope and F_e is the focal length of the eyepiece. For example, a 1000 mm telescope fitted with an 8 mm eyepiece will give a magnification of 125×. Note that the focal ratio of the telescope has no effect on magnification, which is dependent only on the focal length. The focal ratio does, however, play a role in the characteristics of the eyepiece image. The width of the image exiting the eyepiece, called the exit pupil diameter and denoted P, is given by:

$$P = \frac{F_e}{f}$$

Where f is the focal ratio. Let's assume our example telescope has a focal ratio of f/10. An 8 mm eyepiece will produce a 0.8 mm-wide exit pupil. Fortunately, the muscles in our neck and eyes are extremely adept at stabilising us when looking at such a narrow beam of light. It's virtually effortless. By contrast, holding up a smartphone camera to take a photo through the eyepiece is notoriously difficult, because our arms and hands are relatively clumsy and we're trying to align a small camera lens with a beam of light typically less than a millimetre wide.

A wide variety of eyepiece designs have been advanced over the past four centuries, with more sophisticated arrangements of lens elements bringing wider fields, greater viewing comfort and better correction for aberrations. Aside from the focal length, the other two values usually given for an eyepiece

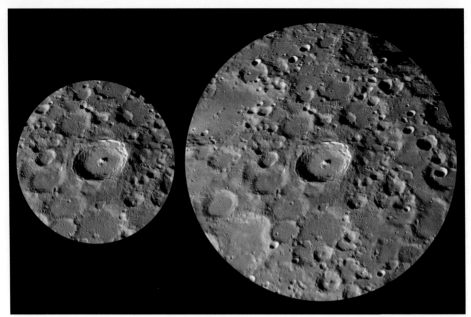

Simulated comparison between a typical eyepiece (left) and a wide-angle eyepiece at the same magnification.

are the eye relief (in mm) and the apparent field of view (in degrees), both of which will be quoted in the specifications. Eye relief is a measure of the distance between the eye lens (the glass surface at the top of the eyepiece) and the surface of the eye, where the whole image can be seen. Longer eye-relief entails more comfortable viewing. For some eyepiece designs, the eye relief is a function of the focal length, but there are many 'long eye relief' (LER) eyepieces on the market, specifically engineered to offer around 20 mm of eye relief. The apparent field of view indicates the size of the image as it appears to the eye. Earlier eyepiece designs had very narrow fields of view, but today a typical inexpensive eyepiece will offer a generous 50 degrees. Wide-angle designs have pushed the boundaries ever further, with some exceeding 100 degrees. They deliver an immersive experience, as the image reaches into your peripheral vision, which is particularly impactful when viewing the Moon at high magnification. It gives the impression of flying over the lunar surface,

whilst looking out through the porthole window of your own spacecraft! Since most of the objects in our Solar System show a small angular size, wide-angle eyepieces aren't necessary to enjoy them and some of the best planetary eyepieces inherently have narrow fields of view. The following is a summary of some of the popular eyepiece designs on the market today.

KELLNER

The Kellner eyepiece is perhaps the most common budget eyepiece design in circulation today. Made of three elements, they are inexpensive to produce and perform well on telescopes with a high focal ratio of f/10 or greater, offering an apparent field of view of about 45 degrees. At faster focal ratios, this design struggles to parallelise incident light rays for a good image. Budget telescopes often include Kellner eyepieces in the box to pad out the perceived value, but for high-magnification viewing they're not very comfortable. Kellner eye relief scales with focal length, thus the short focal

lengths needed to zoom in on the planets will result in very short eye relief. If your eyepiece collection is made up of Kellners, consider upgrading, starting with the short focal length end of the range.

PLÖSSL

With a four-element design, the Plössl improves upon the Kellner design with comparable on-axis performance, a wider field of view (typically 50–55 degrees) and better eye relief. A 10 mm Plössl offers 6.5 mm of eye relief, and is a commonly included accessory with beginner telescopes from reputable manufacturers. Plössl eypieces hold up better at faster focal ratios than their Kellner equivalents, but with somewhat noticeable curvature near the edges of the field. Nevertheless, they offer probably the best overall performance-to-cost ratio, and make an excellent starting point. Eye relief becomes an issue for Plössl's with focal lengths shorter than 8 mm.

ORTHOSCOPIC

The orthoscopic (sometimes 'Abbe' after its inventor) is a four-element eyepiece design that sacrifices some apparent field of view (yielding at most 45 degrees) for exceptional, distortion-free performance. Also giving good eye relief, it is arguably the eyepiece of choice for planetary viewing. Orthoscopic eyepieces provide somewhat narrow apparent fields of view, around 45 degrees, but with good tracking they are excellent for observing fine details and colours. They're lauded for offering some of the highest contrast of any eyepiece design.

MODERN DESIGNS

The eyepieces discussed above were introduced in the 1800s, but there have been many more variants in the modern age. Most discard simplicity for sophisticated ensembles of many lens elements in numerous groups. In the past, this would have resulted in lower light transmission and increased aberrations, but today's range of high-quality glasses, manufacturing tolerances and superb coatings make possible some extraordinary designs. Ultra-wide and LER eyepieces are available at a premium, offering fields of view in excess of 70 degrees with a comfortable 20 mm of eye relief, even at very short focal lengths. An eyepiece collection is like a lens collection for your camera. It will stay with you as you change and upgrade your telescope, and it will in turn be upgraded one piece at a time. As a beginner, you should start with the eyepieces that come with your telescope, and then look to expand your collection to support a range of magnifications.

You will also find a number of zoom eyepieces sold by astronomy retailers. On the cheaper end, these are poor performers that should be avoided. Premium models, such as the TeleVue Nagler Zoom, can simplify your planetary eyepiece collection; however, when new to the hobby, there are inexpensive and effective ways to achieve higher magnifications.

IMAGE AMPLIFIERS

Image amplifiers can be used between the eyepiece and the telescope to increase the magnification of the system. In effect, these amplifiers change the properties of the telescope as seen by the eyepiece. For example, a 2x amplifier in an f/10 telescope will make it perform as if it were a native f/20 instrument. It doesn't affect the aperture, but doubles the effective focal length. Therefore, any given eyepiece will provide 2x the image scale when placed in the image amplifier.

A Barlow lens is an excellent investment that will potentially double the size of your eyepiece collection and provide other benefits. A Barlow lens uses a fairly simple arrangement of two lens elements to elongate the light-cone from the telescope. A sufficiently well-made Barlow will increase magnification without

Generic Barlow lens.

TeleVue PowerMate.

introducing noticeable aberrations, and will also increase the eye relief of the eyepiece. Barlow lenses are available between 1.5× to 3× magnification, with 2× being the popular sweet spot. Suppose your new telescope comes with a 10 mm and 25 mm eyepiece. With the addition of an affordable Barlow lens, you now have (effectively) a 5 mm, 10 mm, 12.5 mm and 25 mm eyepiece collection. Furthermore, many Barlow lenses include a T2 camera adapter thread and removable lens cell, so they double up as a use accessory for budding astrophotographers. In Section 7, we'll see how this is used.

3× Barlow lenses have become increasingly popular, but only those by reputable manufacturers should be considered. Cheap 3× Barlows are usually poorly corrected and introduce aberrations. Beware of supposed '5×' Barlow lenses – the Barlow design is not suitable for this degree of amplification, and respected manufacturers don't sell them for this reason.

TeleVue offers the popular PowerMate range of image amplifiers, which employ a four-element design. They are telecentric lens systems, which amplify the image by up to 5×; however, the light rays exit the PowerMate in parallel, rather than on diverging paths as with a Barlow. As a result, PowerMate amplifiers can be stacked without degrading optical performance, and the eyepiece behaves as though it were in a natively longer telescope. Some other manufacturers have introduced 5× amplifiers as alternatives to the PowerMate, which have similar characteristics. They are sometimes marketed as Barlow lenses, but most are four-element designs – not strictly Barlows by design.

FILTERS
Eyepieces are threaded inside the barrel to accept filters, which can be screwed firmly into place before the field lens. There are many Solar System specific eyepiece filters available, which prevent certain colours of light from reaching the eye in order to enhance contrast. Filters are made from glass, with extremely fine layers of material deposited on top, and like eyepieces they

should be treated with care. Here we'll look at the types of filters popular with Solar System observers.

A Moon filter provides a fixed neutral density value, whereas a variable polariser can be set to an arbitrary value.

NEUTRAL DENSITY AND MOON FILTERS

The Moon is the second brightest object in the sky, and the brightest in the night sky. Although the Full Moon is about 400,000 times fainter than the Sun, it can be dazzling when seen through a telescope. A Moon filter reduces the brightness of the image, cutting down the glare of the sunlit lunar surface. This reduces the fatigue you might otherwise feel in your eye when viewing for an extended time. A Moon filter is a form of neutral density filter – it doesn't discriminate by the wavelength or colour of light. Rather, it reduces all light transmission by the same amount. Neutral density filters are rated by the ND number. An ND3 filter reduces light transmission to $10^{-0.3}$ or 50%; an ND6 filter to $10^{-0.6}$ or 25%; and ND9 filter to $10^{-0.9}$ or 12.5% (often rounded to 13%). ND6 and ND9 are commonly rebranded as Moon filters, and they are individually suited to smaller and larger telescopes, respectively. Sometimes an ND filter is also given the number 96. This is the Wratten number, and it describes the colour (grey). As we'll see, planetary colour filters are each identified by a different Wratten number.

The Moon's brilliance changes throughout the lunation, so you may wish to upgrade from a Moon filter to a variable polariser. This double stacked filter system employs two polarising filters, one of which can be rotated. As the angle between the two filters is changed, so too is the light transmission. In practice, the transmission ranges from about 5% to about 40%, and you can set a completely arbitrary reduction in brightness between these values, depending on the

Planetary filters of various colours.

aperture of your telescope and the lunar phase.

PLANETARY COLOUR FILTERS

When viewing the planets, it is possible to enhance certain features using colour filters. Of course, this will change the hue of the entire image, giving a very unnatural impression. The purpose of these filters is to selectively improve contrast. The table lists colour filters, their Wratten number and common uses. In Section 5, you'll find suggested filters alongside specific targets. Note that some colour filters are also useful when viewing the Moon.

In almost all cases, these filters have multiple uses across the various worlds in the Solar System, but be aware that filters always reduce light, and any observed brightening is just an apparent effect – an increase in perceived contrast from the relative darkening of features for which the most prominent colour is rejected by the filter. Darker filters will generally be too aggressive for small aperture telescopes.

SPECIALIST FILTERS

Moon and colour filters are often sold together in sets, which offer excellent value for the beginner. Beyond these common filters, there exist many unique specialist filters that serve a specific purpose.

Any telescope can be adapted to safely observe the Sun if properly filtered.

Caution:
For observation of the Sun, a solar filter must be fitted over the entire aperture of the telescope. An eyepiece filter is not sufficient. An unfiltered telescope pointed at the Sun will focus intense light and heat into the eyepiece. Viewing the Sun through an unfiltered telescope will cause permanent eye damage!

Wratten number	Colour	Common uses
8	Light yellow	Lunar contrast in small telescopes
11	Yellow-green	Cassini Division in Saturn's rings
12	Yellow	Surface features and clouds on Mars
15	Amber	Martian polar ice caps and clouds on Venus
21	Orange	Lunar contrast and Jupiter's Great Red Spot
23A	Light red	Martian surface features, polar caps and clouds
25	Red	High-altitude clouds on Venus
29	Dark red	Transits of Jupiter's moons in large telescopes
38A	Dark blue	Jupiter's equatorial belts and Great Red Spot
47	Violet	Clouds on Venus and Saturn's rings
56	Light green	Martian polar ice caps and dust storms
58	Green	As above with more contrast in large telescopes
80A	Blue	Lunar contrast and Gas Giant storms
82A	Light blue	Martian surface features and Gas Giant storms

Baader AstroSolar film for solar viewing.

A Celestron Mars filter.

Solar filters are fitted at the front of the telescope. Baader AstroSolar film is a material that can be cut to size and assembled into an effective and safe solar filter that will allow you to see details in the Sun's photosphere (effectively the 'surface' of the Sun). You should always carefully inspect a filter before using it, by holding it up in sunlight and checking its shadow for any bright spots that indicate perforations in the filter.

Baader also produces a special solar continuum (green) filter that enhances the contrast of sunspots and their surrounding regions. This filter is fitted to the eyepiece and used in conjunction with the full-aperture filter. A special solar telescope can also be used, and this is briefly discussed in Section 5.

Both Orion and Celestron produce eyepiece filters specifically designed to improve the

A Baader solar continuum filter.

A 'Semi APO' designed to reduce chromatic fringing in refractor telescopes.

visibility of features on Mars. They attenuate certain colours to transmit an image with higher contrast, but without the unnatural tint of a single-colour filter. Similarly, Baader's Moon & Skyglow filter is popular for viewing Mars and Jupiter, as it enhances the contrast of red features.

Some observers choose to use 'Semi-Apo' filters, which purport to improve the view through an achromat refractor by rejecting the violet fringes seen around bright edges, thus providing an image with apparently reduced chromatic aberration, like an apochromatic refractor. Your mileage will vary with these filters, and it would probably be best to try before you buy. Chromatic aberration isn't just a colour fringe – it entails dispersion of light that leads to an overall loss of sharpness that no filter can correct.

Theoretical and Practical Limits

It is important to understand that there are limits to the performance of a telescope. Some very cheap telescopes sold by non-specialist retailers promise exceptionally high magnifications with the included accessories, but whether such magnifications are usable is another matter. As we have seen, a telescope's resolving power is determined by its aperture. We can calculate the typical maximum useful magnification by using the following formula.

$$M_{MAX} = 2D$$

Where D is the diameter of the objective in millimetres. A telescope with an aperture of 80 mm has a maximum practical magnification of 160x. If this telescope were f/10, with a focal length of 800 mm, a 5 mm eyepiece would achieve the magnification limit, producing a 0.5 mm wide exit pupil. Usually, increasing the magnification beyond this limit will enlarge the image, without showing any more detail. As such, the view will begin to appear blurry and dim. This formula is generalised for the precision of common telescope optics. Some expensive, high-end telescopes have extended magnification limits around 2.5D or even 3D, but if the exit pupil is narrower than 0.5 mm, the perception of contrast and detail will be degraded.

It seems possible, then, that with a sufficiently large aperture telescope, extraordinary magnification factors are possible. A 400 mm telescope should be able to achieve 800x magnification. At this scale, Jupiter seen at opposition would appear to be about 10 degrees wide, comparable to the apparent size of your closed fist held out at arm's length. Unfortunately, such

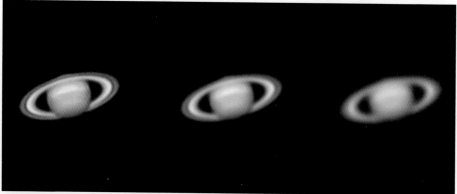

Left to right: simulated appeance of Saturn in good, moderate and poor seeing.

views would rarely, if ever, be possible. It's true that the telescope could magnify the image without degradation, but the image itself will be limited before it reaches the objective. The culprit is the atmosphere, which has its own optical properties. From space, the view of the stars and the Solar System is crystal clear, but from the ground, turbulence and haze in the atmosphere muddies the view. Haze and the presence of particulates in the atmosphere impact its transparency, resulting in a loss of contrast. This effect is less noticeable on bright Solar System objects than diffuse deep-sky objects. Turbulence has a much larger factor, as its effects on the image are exacerbated by magnification. The atmosphere above us is composed of moving cells, which vary in density and temperature. As light from a celestial object passes through, it is refracted and dispersed, and because these cells are moving, the angle and intensity of the refraction changes continuously. Celestial light sources undergo scintillation, which astronomers refer to as 'seeing'. When the seeing is poor, stars twinkle noticeably and when the seeing is good, they appear steady. The Moon and naked-eye planets do not appear to twinkle, even in poor seeing, because they are not point sources, but when viewed through a telescope they appear as if they are underwater. The seeing makes our view ripple, move in and out of focus, and change geometry.

It turns out that even under excellent seeing, the atmosphere causes dispersion that limits our resolution, usually to about one arcsecond. Consequently, magnifications above 250x are rarely viable for visual observing, regardless of the size of the telescope. Astrophotographers have developed tools and methods for reducing the effects of seeing in their images, which we will discuss in Section 7. However, we can't use these visually. We must instead wait for uncommonly superb conditions to enjoy very high magnifications or be lucky enough to live in a location with many nights of excellent seeing. The author has successfully made memorable observations of several planets at 700x magnification through the dry, steady air over the Namib Desert. At home in the UK, such observations are impossible, and it is only on rare occasions (approximately ten nights per year) that clear images at magnifications of 350–400x can be enjoyed. The 7Timer! website, highlighted in the previous section, provides a seeing forecast, allowing you to anticipate good nights for zooming in on fine details.

We cannot control the air currents that disperse light in the atmosphere, but we can at least minimise air currents in our telescopes. The elements inside our telescopes change temperature, and if stored inside, will be warmer than the ambient temperature when we set them up. As mirrors and lenses cool down, they can create 'tube currents' inside the OTA. At low magnification, they're hardly a concern, but you can think of these currents as analogous to the visible heat currents above a radiator, freshly boiled kettle or open fire. They're much more subtle of course, but small effects are amplified at high magnifications. For the best view, it's important to allow your telescope to cool to the ambient temperature. Larger instruments will take longer than smaller ones, and mirrors cool more slowly than lenses. Refractors typically cool fastest, with Newtonian reflectors taking longer, and compound telescopes taking longer still. Large telescopes can take one or two hours to cool down, and should be set outside ahead of your planned observing session. A small refractor will cool in as little as ten minutes, lending it the greatest 'grab-and-go' appeal.

5: OBSERVING THE SOLAR SYSTEM

This section details the prominent objects and events in our Solar System that are suitable for viewing with a telescope. In each case, we'll look at the physical nature of the object, how it appears, what to look out for and how to improve your view. Naturally, how it appears to you will depend sensitively on your telescope and eyepiece combination, where it is in the sky and the conditions of the atmosphere at your observing site. We will consider the view under ideal circumstances, when it is favourably placed (such as during opposition and high above the local horizon) and as it appears with a modest telescope. Each of the objects (and categories) in this section could more than fill an entire book, so we will focus on the highlights for beginners.

Finding any given object in the Solar System is a matter of charting its position and knowing when and where to look. Use Stellarium to determine when the object will rise and set from your location, and calculate its apparent size at the magnifications supported by your telescope and eyepieces.

The Moon

Our celestial companion is the ideal starting point for Solar System exploration. Large and bright in our skies, it's forgiving to the smallest telescopes or binoculars, with an ever-changing surface that invites a lifetime of observing. The Moon's orbit is not circular, but elliptical. It orbits the Earth once every 27.3 days and reaches its perigee – minimum distance to the Earth – once every 27.5 days. As we orbit the Sun, the Moon must complete slightly more than one orbit to reach its opposition, and Full Moons are separated by a lunation period of 29.5 days. When a Full Moon falls close to lunar perigee (a near-perigee Full Moon) the event is sometimes called a 'supermoon'. The variation in the Moon's apparent size is not noticeable by eye, but it does make an impact on observations with a telescope. The disc of the Moon subtends between 29.3 and 34.1 arcminutes as its distance from the Earth varies by 49,000 km.

The Moon is resplendent with interesting features, including the maria (seas) which are large volcanic basins comprising darker rock, impact craters and their ray systems, and valleys and channels. The map

A comparison of the smallest and largest apparent size of the Full Moon, a 'minimoon' and 'supermoon', respectively. The difference is virtually imperceptible to the unaided eye.

Craters	Fairly circular depressions usually formed from impacts. Occasionally, chains of craters are grouped together and collectively termed catena. Craters feature sloped walls and, on many occasions, central peaks, left over from the crater formation, at which point the lunar surface was locally molten by the energy of the impactor.
Mare (pl. maria)	Latin for 'sea'. Large basins of solidified, ancient lava. The maria appear dark relative to the other terrain features. There is one large lunar 'ocean' in the Moon's western hemisphere known as Oceanus Procellarum (Ocean of Storms).
Mons	An individual mountain on the Moon. Lunar mountains were formed by a variety of processes, and vary greatly in size and height. The tallest are approaching 5 km in height, comparable to Vinson Massif, the highest peak in Antarctica.
Montes	Large chains of mountain ranges formed by gigantic asteroid impacts billions of years ago. As with terrestrial ranges, prominent individual peaks often have their own names.
Vallis (pl. valles)	A valley or system of valleys formed by lava flows and collapsed lava tubes. These features snake across the surface, often near craters connected to volcanism.
Dorsum (pl. dorsa)	Derived from the Latin for the 'back', and connected to ridges or fins on the back of an animal, dorsa are subtle features resembling wrinkles in lunar maria. They are hard to see unless illuminated at a low angle, causing them to cast shadows.
Rima (pl. rimae)	Latin for 'fissure'. Rimae, sometimes called Rilles (German for 'grooves') are fissures or cracks in the lunar surface. Not to be confused with valleys, they are often jagged in appearance, with straight sections permeated by kinks. They are seismological features in the Moon's crust, and are sometimes found in crater floors.
Rupis (pl. rupes)	Latin for 'rocks', rupes are escarpments in the lunar surface. They appear as large rifts, where a pronounced change in elevation can be seen. In fact, most rupes are very gentle slopes that are many kilometres wide.
Lacus	Derived from the Latin for an opening, a lacus is a lake, which as its name suggests is a very small lunar mare. These features appear as dark, often patchy regions of dark, smooth plains.
Sinus	Derived from the Latin for a gulf, a sinus on the Moon is a bay formed by a rugged 'coastline' of lunar highlands meeting a low elevation, smooth plain such as a mare.
Palus (pl. paludes)	Though the original Latin name is closer in meaning to a pool, paludes are generally translated as marshes. They are low lying, but relatively rugged regions. Whilst they are not as dark as a mare, they do show relatively low brightness when compared with other types of rugged terrain.

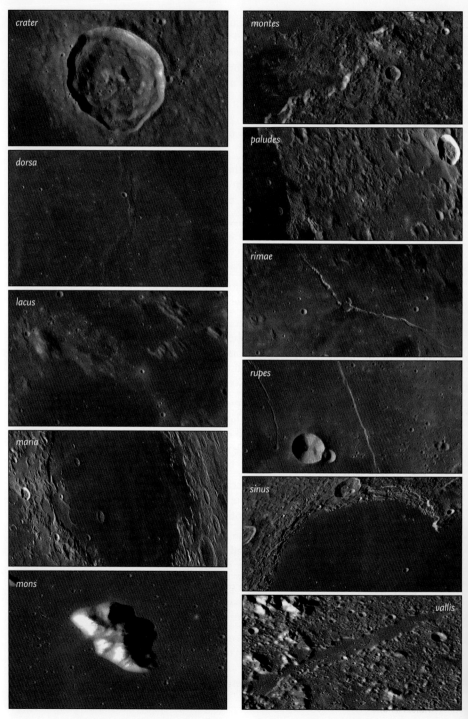

crater

montes

dorsa

paludes

lacus

rimae

maria

rupes

mons

sinus

vallis

highlights major features of interest that are recommended when starting with lunar observation, and for completeness the table includes definitions of features.

There are many detailed atlases of the Moon to help you identify the interesting features you see in your telescope. You can find illustrated charts in the Collins book *Moongazing*, or use one of several excellent apps or resources, such as the Virtual Moon Atlas software outlined in Section 3. Of course, it is not necessary to know exactly what you're looking at to enjoy the sight, but it's useful to familiarise yourself with the locations of some of the larger features in relation to one another.

Since the Moon's orbit is not circular, it changes speed as it travels around the Earth. However, the Moon's rotation rate is fixed at one rotation in 27.3 days. If the Moon's orbit were circular, it would keep one side perfectly pointed at the Earth at all times, but as it changes speed, we are able to peer around the eastern and western limb to see more than half of its surface over a complete orbit. The Moon's orbit is also inclined, bringing it north and south of the ecliptic, and allowing us to see more of its southern and northern polar regions, respectively. In combination, these two effects are called libration, and they allow us to observe a total of 59% of the Moon's surface from the Earth. When the libration is favourable, some interesting features can be seen. For example, during a favourable western libration it is possible to see the Einstein crater's curious structure, appearing as a crater within a crater. Apps and software designed to show you the Moon on a specific date will show the correct libration, so you can determine which part of the limb is most favourable.

The Moon's rugged features are accentuated when the sunlight falls over them at a shallow angle. The line between day and

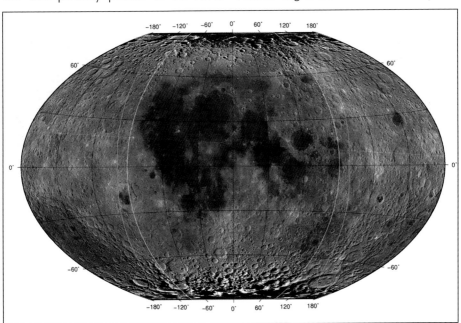

Libration allows us to peer around the edges of the Moon to see 59% of its surface, encompassed in the green lines. Without libration, we would only see 50% encompassed by the yellow lines.

An ehanced colour photograph of the Moon revealing chemical variance.

night – known as the terminator – is an excellent place to explore with your telescope, as mountains and crater walls cast long shadows across the landscape. The Full Moon is arguably the least dramatic phase to view through a telescope, as the absence of visible shadows leaves the surface looking rather flat, but you can still observe the unevenness of the limb.

It is possible to see (and photograph) faint colours on the lunar surface. They are extremely muted, and are best appreciated through digital photography at very high saturation values. With practice, you will notice hints of the natural colour visually, particularly at low magnification.

SUGGESTED FILTERS

As we saw in Section 4, a Moon filter or variable polarising filter is essential for the budding lunar observer. The Moon's brightness is not dangerous to observe, even in very large telescopes, but it is dazzling and can cause eye fatigue.

Some colour filters can enhance the contrast of the Moon's surface. Light

yellow (Wratten #8), orange (#21), violet (#47) and dark blue (#80A) will all increase the visibility of certain surface features. Orange and blue are particularly useful, as they coincide with the main natural hues of the highlands and maria, respectively. The highlands and regions around impact craters are more abundant in iron oxide, granting them a suble orange tint, whereas the flat lowlands of the maria contain relatively high quantities of titanium dioxide, casting them slightly blue. Of the four, the orange filter is the most useful. It darkens the bluer regions substantially, making crater rays more visible. It also steadies the image against poor seeing, as blue wavelengths of light are more severely dispersed. Finally, while it cuts light transmission, it is not as aggressive as a blue filter, so it is more suitable for small and medium aperture telescopes. The use of neutral density and orange filters will also enhance the contrast of the Moon during the day in blue skies, but note that daytime viewing in general is fraught with worse seeing as the air currents are more prevalent when heated by the Sun.

HIGHLIGHTS

The following is a list of highlights for beginners to find on the Moon. They include a range of features that allow us to appreciate the diverse selenology (lunar geology) of the surface.

- Copernicus Crater: this prominent impact crater was named after Nicolaus Copernicus, who advanced the heliocentric theory of the Solar System in the 16th Century. It spans 93 km and has a prominent ray system that is clearly visible over the dark material of Oceanus Procellarum. It is flanked by more than a dozen 'satellite' craters, most of which are just a few kilometres wide, making them good targets for high magnification exploration.

Copernicus Crater.

- Sinus Iridium: the 'Bay of Rainbows', true to its name, appears as a beautiful bay surrounded by mountains. It is believed to be the remains of a large impact crater, which was subsequently flooded with lava early in the history of the Moon. The surrounding mountains and prominences are endlessly fascinating to observe, and the bay offers its own subtle curiosities in the form of dorsa (ridges that look like wrinkles). They take on the appearance of waves lapping into the bay.

Sinus Iridium.

- Aristarchus Plateau: the region around and including Aristarchus crater is of considerable interest to scientists studying lunar history. Aristarchus (named for Aristarchus of Samos, Greek astronomer) is the brightest crater on the Moon, spanning 40 km. Its brightness is attributed to its age – it is considered to be young at about 450 million years. Over time, solar wind darkens exposed lunar material. Aristarchus sits in rocky plateau, elevated above the surrounding Oceanus Procellarum, which includes a collapsed lava tube called Vallis Shroteri. It snakes along the surface, surrounded by small craters.

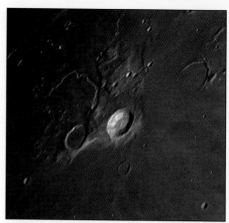
Aristarchus Plateau.

- Tranquility Base: the historic Apollo XI landing site, where astronauts Neil Armstrong and Buzz Aldrin first set foot on the Moon in 1969, is situated in the southern extremes of Mare Traquillitatis – the 'Sea of Tranquillity'. None of the Apollo sites are visible from Earth with ground-based telescopes – they're simply too small to be resolved at such a distance – but you can admire the location around the landing site where history was made. To the west are craters Ritter and Sabine, both about 30 km wide.

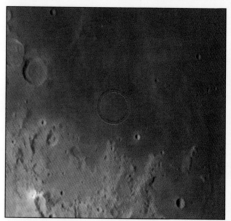
Tranquility Base.

- Lunar Southern Highlands: punctuated by the extraordinary crater Tycho (named for Tycho Brahe, Danish astronomer) and its surrounding rays, the rugged highlands of the far lunar south are always a treat in telescopes. Tycho's central peak casts long shadows across its floor when the sun rises or sets on the near side of the Moon. Further to the south are giant craters Maginus and Clavius, both of which host many 'craterlets' of varying sizes within them. This whole region has been heavily bombarded and looks magnificent at almost every stage of the lunation.

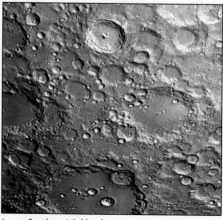
Lunar Southern Highlands.

- Rupes Recta: near the eastern edge of Mare Nubium (the 'Sea of Clouds') lies a very unique feature. Rupes Recta is almost invisible around the Full Moon, but during the crescent phases, it appears as a strangely straight, thin line running along the surface. With scrutiny, it appears to be a sharp cliff edge that casts shadows, but it is in fact a fairly gentle slope. Nevertheless, it's fine enough to leave a lasting impression.

- Lunar X and Lunar V: these two features are fleeting apparitions, caused by sunlight striking the boundaries of some smaller craters in the last hours of the waxing crescent phase. Just before the first quarter arrives, looking along the lunar terminator, you can find the Lunar X at the boundaries of Blanchinus, La Caille and Purbach. Farther north is the Lunar V, formed by the Ukert crater and several of its smaller neighbours. You don't need high magnification to spot these two phenomena, but you will need to plan your observation.

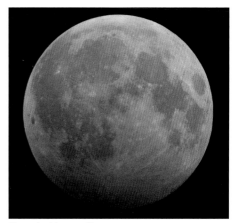
Penumbral lunar eclipse.

LUNAR ECLIPSES
When the Full Moon occurs near its ascending or descending node – crossing the ecliptic – it passes through the shadow of the Earth in space and a lunar eclipse occurs. The Earth's shadow contains two regions: the umbra is the dark, central region; the penumbra is the lighter, outer region. Depending on the Moon's path through the shadow, three different eclipses may occur.

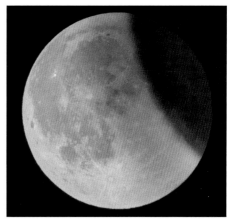
Partial lunar eclipse.

1. Penumbral eclipses occur when the Moon is partially or fully submerged in the penumbral shadow.

2. Partial eclipses occur when the Moon is partially submerged in the umbral shadow.

3. Total eclipses occur when the Moon is totally submerged in the umbral shadow.

Total lunar eclipse.

The penumbral shadow is very diffuse, and it can be difficult to notice the darkening of the lunar surface during a penumbral eclipse. Partial and total eclipses, however, are unmistakable. The umbral shadow is much darker, and also shows a pronounced red-orange colour when projected onto the Moon. The umbra is actually flooded with the light of every sunset and sunrise on Earth simultaneously, and we see this reflected back to us during a partial or total eclipse. Lunar eclipses are not rare, and can usually be seen by a significant fraction of the world's population. You can find the dates and visibility of upcoming lunar eclipses from the timeanddate website and NASA eclipse portal, both of which are linked in the Resources chapter at the end of the book.

Lunar eclipses are perfectly safe to observe by eye or with a telescope, and make great photographic subjects. If you are exceptionally lucky, you may spot an impact on the Moon during a total or deep partial eclipse, which would otherwise be faint to observe against the brilliance of the daylight surface. All notable lunar eclipses occur in conjunction with a solar eclipse, either before or after and separated by just over

Our star is a dynamic object that undergroes a cycle of rising and falling activity.

two weeks. Later in this Section we will see how to safely observer solar eclipses.

LUNAR OCCULTATIONS

The Moon infrequently passes in front of the planets (and bright stars) creating occultations that can be seen by eye or with a telescope. We will return to these alongside conjunctions in Section 6.

The Sun

Caution: directly observing the Sun without proper filters will cause permanent eye damage! Please take extreme care with solar observing.

The Sun is our star, and the heart of the Solar System. It generates all the light we need to see every other world in this guide, and we feel its intense power from a tremendous distance of 150 million kilometres away. As the sole member of a unique category of objects, it requires a special approach to observe.

The Sun is not solid, nor does it have a cloud-top layer like a Gas Giant planet. It is a fluid sphere with an extended, dynamic atmosphere. We can consider the Sun's photosphere to be its 'surface' – this boundary has a much higher density than the surrounding atmosphere, and it radiates brilliantly across the spectrum. The photosphere has an effective temperature

of 5,500 degrees centigrade (9,900 degrees Fahrenheit) and releases an overwhelming amount of visible light. To see it, we must cut down the incident light by a huge amount. When we do so, it is possible to see cooler regions of the photosphere as dark patches called sunspots. These are magnetically active regions where convection from the interior of the Sun is restricted. They appear so much darker than the surrounding surface because they are so much colder at a mere 3,700 degrees centigrade (6,700 degrees Fahrenheit) – cold by the Sun's standard!

Sunspots emerge and evolve over periods of a few days to a few weeks. They can form isolated or in groups, and can change shape or size in a few hours in some cases. The number of visible sunspots changes in line with a long-period cycle that takes 11 years to complete. During solar maximum, the Sun shows sunspots most of the time, occasionally many at once. During solar minimum, the Sun can go without visible spots for long periods. The SpaceWeather website in the Resources chapter features a daily image of the Sun that indicates how many sunspots are visible.

Direct observation of the Sun's photosphere requires properly filtered equipment, but it is safe to observe indirectly by way of projection. A simple pinhole projector will

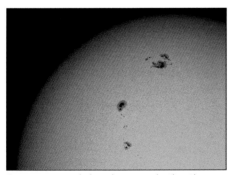

Sunspots appear dark as they are cooler than the surrounding regions.

The Sun projected onto card through the eyepiece of a refracting telescope.

form an image of the disc of the Sun, which shows little detail, but can be used effectively for eclipses. To see visible features on the Sun, it is necessary to project a magnified image. This technique, known as eyepiece projection, involves pointing an unfiltered monocular, binocular or small refracting telescope at the Sun, and using white card or a similar material to view the projected image. Care should be taken to never place your eye near the eyepiece when the telescope is pointed at or anywhere near the Sun. Do not use a reflecting telescope to project the Sun through an eyepiece, as it will cast partially focussed sunlight onto its secondary mirror assembly, resulting in a build-up of heat that can damage the telescope.

WHITE LIGHT FILTERS

ND5 Baader AstroSolar film is safe for solar viewing.

Direct viewing of the photosphere is possible with the use of a 'white light' filter. This is a neutral density filter, which also rejects infrared and ultraviolet, some of which is focussed by the telescope, and which is harmful to the eye. The safest method is to use a full-aperture solar filter, either pre-made to fit your telescope, or homemade from inexpensive Baader AstroSolar film*. The material does not need to be pulled

taught, and the filter must cover the whole aperture of the telescope. If you have a small refractor, you could also consider a Herschel Wedge or Herschel Prism – a white light filter that replaces the star diagonal at the eyepiece end. Such devices must radiate excess heat, usually through a metal plate, which can become exceptionally hot and harmful to touch. These systems are compact and provide excellent images with refractor telescopes, but as a beginner it's advisable to use AstroSolar film at the front of the telescope to begin with.

**Make sure to use the ND5 film for visual observation. It cuts light transmission to one part in 10,000. The ND3.8 film is designed for photography and should not be used visually.*

High magnification solar observing can be challenging, as the seeing is generally worse during the day than the night. However, in steady skies, at higher magnifications you can observe the interesting details around sunspots, as well as the granulation of the photosphere, which is made of towering cells of plasma. Occasionally, you will see bright spots – termed faculae (Latin: 'little torches') randomly situated across the disc of the Sun. They are often more noticeable around the edge, which is dimmed due to 'limb darkening' – the effect of seeing less light emitted towards the Earth than from the centre of the disc. Faculae are intensely hot regions of high magnetic and plasma density that occupy the canyons between cells. Faculae form and dissipate on timescales of minutes.

Using a green filter (Wratten #58) or Baader Solar Continuum filter can improve the white light viewing experience, particularly in achromatic refractors. These filters will allow the peak transmission of the photosphere to pass, whilst blocking wavelengths most susceptable to poor seeing. As a result, the view appears sharper with more perceived contrast.

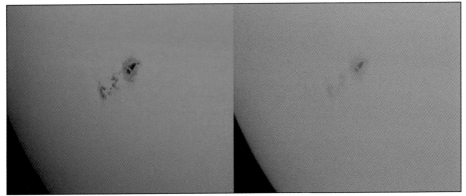

Simulated appearance of the Sun with and without a continuum filter.

NARROWBAND FILTERS

The Coronado PST (personal solar telescope) is one of the most affordable ways to view the Sun's atmopshere.

The Sun is very complex and dynamic, with ultra-high energy events occurring on its surface and in its atmosphere, but its composition is relatively simple. The Sun is mostly made of hydrogen, and we can use this to our advantage. Energised hydrogen will radiate very specific wavelengths of light, according to its electronic structure. The brightest of these is called hydrogen-alpha (Hα) which corresponds to 656.28 nm in the red part of the spectrum. By isolating this wavelength, and rejecting all others, we can see a region of the Sun's lower atmosphere, called the chromosphere. Hα observation requires either a dedicated instrument (such as a Coronado or Lunt telescope) or

an expensive filter system for an ordinary refractor. For beginners, the Coronado PST and Lunt 40 mm telescope offer an affordable Hα experience, but be aware that these telescopes are only designed for viewing the Sun – nothing else in the Solar System is visible with them!

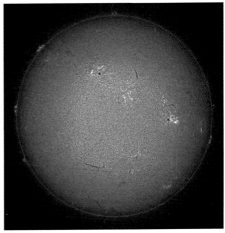

A hydrogen-alpha telescope reveals the Sun's lower atmopshere, where complex magnetic interactions sculpt plasma into dramatic shapes.

In Hα, we see the remarkable interactions that occur between the Sun's atmosphere and its magnetic field. Sunspots are usually surrounded by plage (French: 'beaches') which are bright regions of rich activity. Filaments appear as dark, snake-

like protrusions covering portions of the disc. Prominences, seen leaping from the limb, are ejections of solar plasma that erupt from the chromosphere and rain back down, tracing the spaghetti-like, invisible magnetic field lines. Filaments are prominences seen in silhouette. These features can evolve rapidly or leisurely as the magnetic field and plasma influence each other in an intricate dance. Hα telescopes produce bright red images that take some getting used to – the eye is not often exposed to monochromatic light, which only excites one set of photoreceptors on the retina, and looking into an Hα telescope can feel slightly strange at first. The images you see from such telescopes are usually captured in black and white, and then recoloured to taste by the photographer.

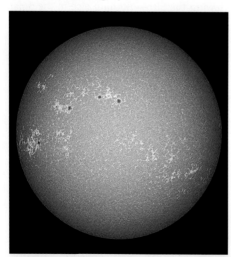

A calcium K-line filter is comparable to a white light filter, but shows greater contrast to those visually responsive to its image.

Another popular narrowband filter isolates the calcium K-line (CaK) which falls at 393.37 nm – the far violet end of the spectrum. Calcium is not very abundant in the Sun, but there is nevertheless enough K-line emission to form an image in a telescope. CaK viewing resembles white light, but with considerably greater contrast. It enables us to see deeper into the chromosphere than Hα, revealing plages, faculae and granulation. Lunt and Daystar manufacture CaK filters that can be used with refractor telescopes, but they are more popular for imaging applications than visual use. For those who can see the CaK line, the sight is quite striking, but many people don't see much at this wavelength. The visible spectrum begins at around 400 nm, meaning CaK is on the threshold of what the eye can detect, and sensitivity to violet lessens as we age. This is one to try before you buy.

SOLAR ECLIPSES

By a wonderful coincidence, the Sun and Moon appear to be almost the same apparent size in the sky. The Sun is approximately 400 times farther away from us and approximately 400 times larger than the Moon. We have seen that when the Full Moon occurs as it crosses the ecliptic, it will pass through the shadow of the Earth, causing a lunar eclipse. Such events necessarily precede or follow a solar eclipse, which occurs when the New Moon falls at the ascending or descending node of its orbit. If the New Moon shares its position in the sky with the Sun, it will pass in front of it, casting a shadow on the Earth. As with lunar eclipses, there are three kinds of solar eclipse.

1. Partial solar eclipses occur when the Moon obscures part of the Sun, giving it a crescent shape.

2. Total solar eclipses occur when the Moon completely covers the Sun for a brief moment (totality), revealing its extended atmosphere – the corona.

3. Annular eclipses (sometimes 'ring of fire eclipses') occur when the Moon passes entirely in front of the Sun, but appears too small to cover it, leaving a bright ring of light visible (annularity).

Partial solar eclipse.

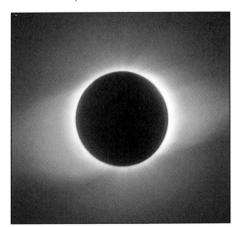

Total solar eclipse.

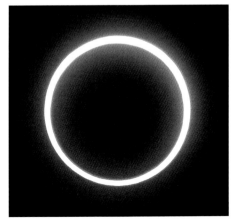

Annular solar eclipse.

The Sun's apparent angular size varies between 31.5 and 32.5 arcminutes as the Earth moves between the farthest point in its orbit (aphelion) and the closest point (perihelion). The average angular diameter of the Moon is 31.7 arcminutes. Because the Moon appears, on average, slightly smaller than the Sun, about 60% of all central eclipses are annular and about 40% are total. Central eclipses are not very rare – they occur on average once every 18 months somewhere on Earth – but it takes on average several centuries for such eclipses to recur over any given location. Therefore, you'll likely need to travel to witness one of these. Fortunately, partial eclipses are more common, and all total and annular eclipses also produce partial eclipses that are much more widely visible. Upcoming solar eclipse information is available from the timeanddate website and NASA eclipse portal, both linked in the Resources chapter at the end of the book.

A colander makes an effective pinhole projector for safely viewing solar eclipses.

Any equipment suitable for viewing the Sun can also be used to observe an eclipse. In fact, a pinhole projector becomes maximally useful during an eclipse, as it reveals the shape of the solar disc. Pinhole images of

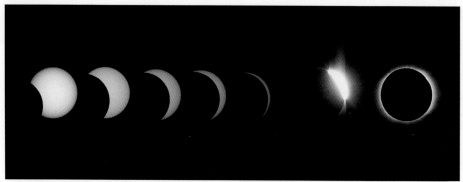

The progress of a total solar eclipse. A dazzling diamond ring is seen either side of totality.

the Sun become crescent-shaped during an eclipse. You can use any perforated object to see these crescent images – even a colander! When an eclipse is looming, you will see retailers selling eclipse-viewing glasses, which use solar film (often tinted yellow for effect) to make looking at the Sun safe and comfortable. You should purchase a pair 'off season' as the prices always go up before a solar eclipse.

The only time that it is safe to view an eclipse directly, without a filter, is during the totality of a total eclipse. For a short time, you can see the Sun's corona extending into space, as well as bright stars and planets around it. It is a truly spectacular and arresting experience, so be careful not to stare when the totality ends. Immediately either side of totality, the eclipse appears as a 'diamond ring' with the last (or first) sunlight forming the blazing jewel. The jewel briefly fades out and re-emerges as a number of small, bright spots called Bailey's beads. These are rays of sunlight spilling through the valleys of the rugged lunar limb.

The Inferior Planets

The two innermost planets – Mercury and Venus – are collectively known as the inferior planets because the sizes of their orbits are inferior to that of the Earth. As they are closer to the Sun than us at all

Simulated view of Mercury as seen with a telescope during a gibbous phase.

times, their behaviour in the sky is quite different to the other planets. They can never be seen at opposition, or throughout the night, and may on rare occasions transit in front of the Sun.

MERCURY

Mercury is the smallest planet in the Solar System. It is also bound in the smallest orbit, taking it around the Sun once every 88 days. It is among the most challenging to observe, because from many locations – particularly built-up areas – it is seldom clear of obstructions on the horizon when the sky is sufficiently dark to see it. Mercury is usually visible during a fairly narrow window after sunset or before sunrise.

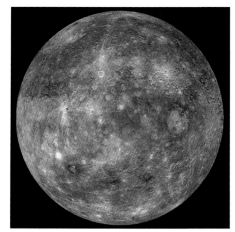

Mercury revealed in detail by the MESSENGER spacecraft.

Mercury is a rocky world with no appreciable atmosphere. With a dimeter of 4880 km, it is only 40% wider than the Moon, and presents a very small disc with an apparent size that varies between 4.5 and 13 arcseconds. The maximum end of this scale occurs only when Mercury transits in front of the Sun. Typically, we see Mercury when it is around its greatest elongation – its largest apparent separation from the Sun – with an angular size of around 7 arcseconds. The greatest elongation of Mercury can never exceed 28 degrees from the Sun, and varies due to Mercury's orbit being quite non-circular. Mercury's orbit changes its distance from the Sun by nearly 24 million km between aphelion and perihelion. When an inferior planet is physically closer to the Sun in its orbit, it is also apparently closer to the Sun and therefore harder to observe in the bright glare of sunset or sunrise. Conversely, superior planets (which we will begin to explore in the next chapter) are more favourable when they're closer to the Sun.

Despite its small size and lack of reflective cloud tops, Mercury is bright enough to be visible to the unaided eye and clearly resolved at high magnifications. We know from probes that have visited the planet that it is a heavily cratered world, with an interesting surface reflecting a violent history, but in small telescopes it only shows a featureless disc.

When viewing Mercury with a telescope, take care to ensure that the Sun is completely below the horizon, so there is no risk of direct sunlight entering the telescope.

SUGGESTED FILTERS
Surface features on Mercury can only be seen with large telescopes, and in very good seeing at high magnification. The use of a

Mercury is a heavily cratered, barren world.

Simulated view of Venus as seen with a telescope during a crescent phase.

filter is almost essential. An orange filter (#21) will simultaneously improve the steadiness of the image and increase surface contrast, and is probably the best colour filter to use for Mercury. You can also increase contrast with a blue (#80A) or light blue (#82A) filter, the latter being more forgiving with greater light transmission. However, blue light is the most susceptible to scintillation in the atmosphere and should be avoided unless the seeing is excellent.

VENUS

The observation characteristics of Venus are similar to those of Mercury, but better and more impressive in every way. While Mercury is, on average, the closest planet to the Earth, Venus comes nearer to our planet than any other – not only in distance, but also in size. Its diameter is just 5% smaller than the Earth's. We know of its rocky, volcanic surface from radar observations, as well as a small number of successful landers that have touched down there, but at the eyepiece of the telescope, we only see the top of a thick atmosphere that blankets the entire planet. It traps so much heat from the Sun, that the surface temperature of Venus exceeds that of Mercury, and the atmospheric pressure is an astonishing 95× greater than here on Earth. This is equivalent to diving to a depth of 950 metres under water. This heavy atmosphere is almost entirely made of carbon dioxide, so altogether a trip to Venus would be very unpleasant. It might just be the most hellish world in the Solar System.

To our eyes, it's a serene sight – the brightest planet and the third brightest natural object in the sky. Venus reaches a maximum elongation from the Sun of 47 degrees, so it can be seen well after sunset or before sunrise for much of its apparition. It is sometimes traditionally called the morning star or the evening star, depending on whether it is west or east of the Sun, respectively. We can observe most of its phases, from a slender crescent to a

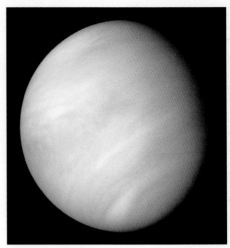

The entire surface of Venus is obscured by thick clouds that appear largely featureless.

healthy gibbous. During the crescent phases it subtends as much as one arcminute in the sky, and is still wider than 45 arcseconds when it is 30 degrees from the Sun. During a transit of Venus, at inferior conjunction, it can appear as large as 66 arcseconds. For the most part, even binoculars will reveal the phases of Venus.

With a telescope, Venus shows little to no detail unless filters are used. The Venusian clouds are active, but the contrast of the cloud features is low. Over several centuries, many astronomers – including highly respected observers – have reported seeing transient patches of light on the night side of Venus, and diffuse light that makes large portions of the night side visible during crescent phases. It is called ashen light, but its nature is not well understood – indeed, its existence is disputed. It could be that ashen light is attributed to an optical illusion, or a fault in the telescope eyepiece. Alternatively, it may be some real phenomenon in the Venusian atmosphere, such as a form of lightning, electroluminescence or volcanic emission. It is a long-standing mystery waiting to be solved. For this reason, ashen light is

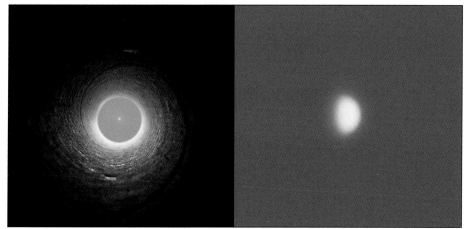

Venus can be found by eye as a star in blue sky during the day. A telescope will improve contrast and make the phase visible.

considered by some to be a white whale in planetary observing.

Venus is at times so bright that it can be seen during the day with the unaided eye as a star in blue skies. With very low contrast, and no surrounding stars (except the Sun) to guide you, it's a challenge to find, but a rewarding and fun observation to make. You might find it easier to observe by looking through a tube of some kind, such as a rolled-up sheet of paper, as this will allow our eye to adjust to the low contrast of the sky, free from the glare of the Sun.

SUGGESTED FILTERS

Because Venus appears so bright, we can comfortably filter its light for contrast, even in small telescopes. The goal with using filters is to improve the visibility of cloud formations. Experiment with red (#25), dark blue (#38A) and blue (#80A) to separate the shades in the upper cloud layer. Be aware that the dark blue filter has a low transmission, and will dim the image more than most. If you have a large telescope (8″ aperture or larger) you can try violet (#47) sometimes fondly known as the 'Venus filter'. It has a very low transmission, and passes light that is very susceptible to perturbations in the atmosphere, but it is widely considered to be the most effective way to enhance Venusian clouds. It's a good investment for a large telescope, but you will find this filter to be quite ineffective on the other planets, so be sure that you really like Venus!

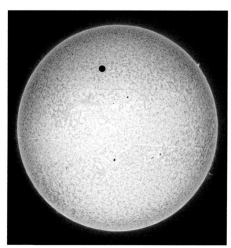

The 2012 transit of Venus as revealed with a dedicated hydrogen-alpha solar telescope.

TRANSITS OF MERCURY AND VENUS

When the inferior planets overtake us, they are said to be at inferior conjunction. Rarely, this coincides with the planet crossing the

ecliptic, causing a transit in front of the Sun. During a transit, we see only the night side of the planet in silhouette against the Sun's disc – a perfectly circular black spot that sails silently across the disc over a period of several hours. We can observe these events safely just as we would any other feature on the Sun – either by projection or with a filtered telescope. During transits, we see these planets at their maximum apparent size. At up to 66 arcseconds, Venus can appear large enough to be visible to the unaided eye through eclipse viewing glasses. Mercury is much smaller, with a maximum apparent size of 10 or 12 arcseconds during a transit.

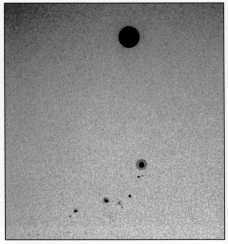

In transit, Venus subtends nearly a full arcminute. This white light image also shows sunspots and granulation on the solar surface.

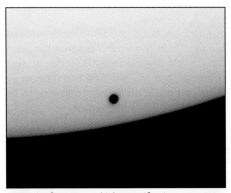

A transit of Mercury at high magnification, seen through a white light solar filter.

Transits of Mercury occur approximately 13 times per century, either in May or November. The table lists every upcoming transit for the 21st Century, with dates given in Universal Time. The last transit before the publication of this book (pictured) occurred on 11 November 2019.

2032 Nov 13	2065 Nov 11–12
2039 Nov 7	2078 Nov 14
2049 May 7	2085 Nov 7
2052 Nov 8–9	2095 May 8–9
2062 May 10–11	2098 Nov 10

Transits of Venus are considerably rarer. They occur in pairs, with two December transits or two June transits separated by 8 years, but the time between these pairs is more than a century. The last two transits occurred in June 2004 and June 2012. The next transit of Venus will occur in December 2117, a little over 95 years after the first publication of this book! (If you are reading this in 2117, I wish you very clear skies from beyond the grave!)

BLACK DROP EFFECT
During transits of Mercury and Venus, as the planet enters or leaves the Sun's disc, the so-called 'black drop effect' can be seen. It is more pronounced with Venus than Mercury, and was once thought to be an optical effect caused by the Venusian atmosphere or the Earth's atmosphere. However, the black drop effect has been observed from space, and it is now thought to occur as a result of the deep limb darkening at the very edge of the solar disc. It has been remarked upon for centuries and is worth looking out for, if your observing site is situated to view the ingress (start) or egress (end) of the transit

Simulated view of Mars as seen with a telescope close to opposition.

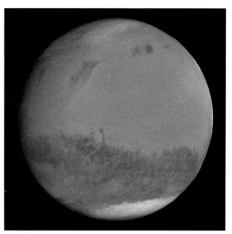

The Martian landscape has captivated us since it was first revealed in detail.

Mars

Mars is the first of the superior planets – worlds with orbits superior in size to that of the Earth. Because these worlds never come between us and the Sun, it is impossible for them to show crescent phases. However, because we overtake them, they will routinely be seen at opposition, placing them high in the sky around midnight. Superior planets begin their apparition in the morning sky before dawn. We see them on the far side of the Sun, and as we move around on our fast orbit, they appear to migrate westward, rising early each night. As we overtake them, they appear high in the south (or north if viewed from the southern hemisphere) at midnight when the sky is darkest. This is the opposition period, after which we begin to leave the planet behind again. It gets fainter and smaller from our point of view, but rises earlier, until it follows the Sun after sunset. Because Mars is a fast-moving planet, orbiting the Sun in 687 days, we do not catch up to it every calendar year. Consequently, apparitions of Mars last several months and occur roughly once every two years.

It is at opposition that planets are ideally situated for observation, and this is true of Mars more-so than any other. Mars is a physically small planet – larger than Mercury but only 53% of the Earth's diameter, with a theoretical apparent size that varies between 3.5 and 26 arcseconds. It reaches its largest sizes if the opposition occurs close to Earth aphelion and Mars perihelion. A typical 'great opposition' provides a disc that exceeds 20 arcseconds in diameter – a poor opposition brings Mars' diameter to just under 14 arcseconds. The last great opposition of Mars occurred in 2003, when the planet subtended 25.1 arcseconds.

Mars is a fascinating planet to observe, partly because it generates so much interest in the worlds of science and science fiction. Of all the other planets in our Solar System, it is the most likely to be, or to have been habitable (although it is not the only world suspected of being capable of harbouring life). It is also the next logical destination for human explorers after the Moon. Relatively nearby, rocky and with abundant surface features (and occasional visible clouds), the red planet has inspired many storytellers, including H. G. Wells, whose 'War of the Worlds' is arguably the first extra-terrestrial invasion story. Whilst we feel quite comfortable in the knowledge that there

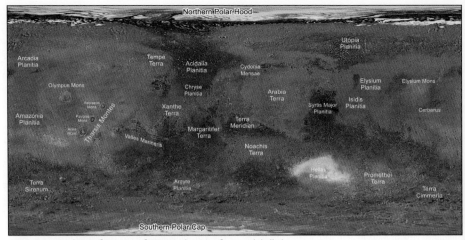

An equirectangular surface map of Mars with major features labelled.

are no alien intelligences on Mars, drawing their plans against us, the planet does offer scientists hints that something might once have flourished there.

Mars has a dusty, orange-brown colour – very evident in the eyepiece of a small telescope, with substantial dark brown markings across its surface. These are similar to the Moon's maria – basalt-rich regions that reflect less sunlight than the surrounding deserts. Two of these regions – Syrtis Major Planum and Mare Acidalium – are particularly easy to identify, but there are many more to tease out on nights of good seeing. Like the Earth, Mars has two polar ice caps and an axial tilt that entails seasons in its two hemispheres. The ice caps are distinctly brighter than the rest of the planet's surface, but only one can be clearly visible at any given time. More challenging surface features include the awesome Valles Marineris, a huge canyon roughly 4,000 km in length, and a collection of gigantic, extinct volcanos in the Tharsis region including Olympus Mons, the largest volcano in the Solar System.

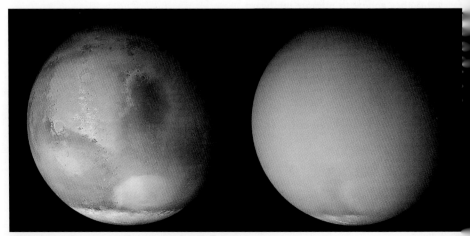

Global dust storms can engulf Mars, obscuring its features.

On rare occasions it is possible to see cloud formations on Mars, and – rarer still – planetwide dust storms that engulf the planet, hiding its surface. These are more common in the Martian northern summer, when the planet is relatively close to the Sun, but they do not occur during every apparition. Mars is also home to two moons – Phobos and Deimos – which are nothing like our own companion. They are tiny and irregular rocks, which were possibly captured from the asteroid belt in the distant past. They are considered advanced targets so we will not cover their observation here. Fortunately, the Gas Giant planets offer many accessible opportunities to see extra-terrestrial moons.

HIGHLIGHTS

- Syrtis Major Planum: close to the Martian equator, this prominent, dark feature was formed by an ancient shield volcano. It is a vast plain approximately 1,000 km wide. In a small telescope, it appears nearly triangular, like an arrowhead pointing to the northern polar region. Syrtis Major Planum is one of the most easily identifiable features for small telescopes.

- Valles Marineris: the 'Mariner Valley' is a vast canyon that dwarfs anything we see on Earth. Compared with the Grand Canyon, it is about five times longer, five times deeper and up to 20 times wider. It seems a variety of processes have sculpted this feature over its long history, including erosion from water, lava channelling and the changing thickness of the planet's crust. In telescopes, it can be hard to trace the full extent of the canyon, but with practice it will become a familiar sight.

- Hellas Planitia: found to the south of Syrtis Major, the Hellas basin is one of two colossal impact craters formed on Mars by a planetesimal or large asteroid billions of years ago. It has a high albedo

relative to the surrounding regions, and appears as a slightly brighter patch in the southern hemisphere. Hellas has been known to freeze over and form frosty clouds that further brighten it, giving it the appearance of a vast polar ice sheet.

- Tharsis Montes: a trio of similar sized, extinct shield volcanos form a pleasing line in the Tharsis region, to the west of Valles Marineris. As with the canyon, they are not easily distinguished by their colour, and will require high magnification and good seeing to make out.

- Olympus Mons: dwarfing even the impressive Tharsis Montes, Olympus Mons is a volcano unlike any other. It is the tallest mountain in the Solar System with a summit elevation of 26 km above the surrounding plains. The entire volcano spans 600 km and is approximately the same size as the country of Poland. In our telescopes, this mighty formation looks small – almost cute – but it was once a truly fearsome cauldron. At about 3.5 billion years old, it is the youngest significant volcano on Mars. Olympus Mons and Tharsis Montes will occasionally form orographic clouds in the ultra-thin Martian atmosphere, making them more conspicuous with the use of colour filters.

- Polar Ice Caps: the northern and southern polar ice caps are noticeably brighter than the rest of Mars, particularly around the solstices. They consist primarily of water ice, with dry ice (frozen carbon dioxide) present as well. As with the larger dark features, the ice caps come into view at low-medium magnifications of around 50–70x.

SUGGESTED FILTERS

Compared with the muted tones of Mercury's grey surface and Venus' creamy

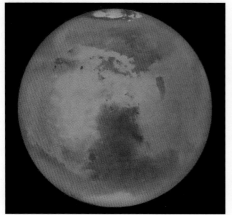

Syrtis Major Planum.

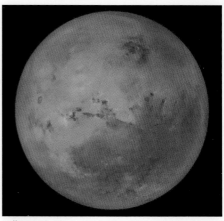

Valles Marineris.

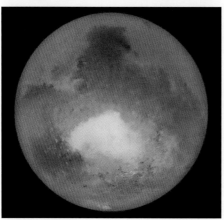

Hellas Planitia.

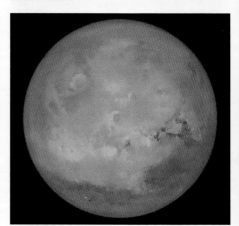

Tharsis Montes.

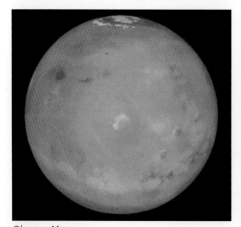

Olympus Mons.

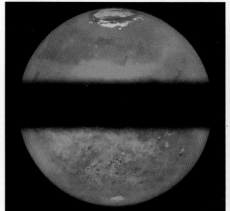

Polar Ice Caps.

cloud tops, Mars is a vibrant world, and every type of colour filter will alter and improve contrast for one or more types of features. Without a doubt, the two most impressive filters are yellow (#12) and light red (#23A) with the latter often being considered the essential Mars filter. Yellow tends to brighten atmospheric clouds whilst darkening maria – useful when the weather is busy on Mars. Light red darkens maria while highlighting dust clouds and the polar caps. A similar effect can be achieved with red (#25) but the transmission is lower than light red, and will make the image quite dim at high magnification. Polar caps and clouds can also be enhanced with blue and green filters, particularly light green (#56), green (#58), blue (#80A) and light blue (#82A). Again, the light filters transmit more light, and are more suitable for smaller telescopes. You can also try dedicated Mars filters from Orion and Celestron, as well as the Moon & Skyglow filter from Baader, which is often reported to perform well on Mars.

Ceres and the Main Asteroid Belt

We are taking a short break from our tour of the planets to investigate the Main Asteroid Belt, which occupies the space between the orbits of Mars and Jupiter. It comprises trillions of fragments of rock and metal – leftovers from the formation of the Solar System – only a small fraction of which have been observed and catalogued. It sounds busy, but despite science fiction depictions of asteroid fields, the Main Asteroid Belt is virtually empty. The objects it contains are vanishingly small compared to the space between them. The Main Asteroid Belt contains a handful of significant objects, the largest of which is Ceres. Although it is small, it has achieved hydrostatic equilibrium, becoming somewhat spherical in shape, and is considered to be a dwarf planet today. Ceres is the brightest object in the asteroid belt with a magnitude ranging between 6.6 and 9.3, making it readily visible in binoculars and small telescopes. However, with a diameter of just 950 km, beyond the orbit of Mars it subtends a mere 0.85 arcseconds at best. Recall that the atmosphere typically imposes a resolution limit of about one arcsecond. With an amateur telescope, Ceres will always appear as a point of light. This is also true of all observable asteroids, the brightest of which are tabled below. None are larger than Ceres, but the largest asteroid – Vesta – does have a peculiar quality. At 525 km wide, it is substantially smaller than Ceres, but it is also closer to us for almost all of its orbit. It turns out to be the brightest object in the asteroid belt, and during a favourable opposition it can brighten to above magnitude 6, bringing it within naked-eye visibility. It appears as a very faint star in ideal skies, and you will need to know exactly where to look to find it, but it is a rewarding challenge. The second brightest asteroid, Pallas, also outshines Ceres, but it is too faint for naked-eye observation. The sight of asteroids drifting among the stars is an important reminder that the Solar System is still a shooting gallery, and that collisions with Earth are inevitable. Hopefully we will be able to avert the next disastrous impact.

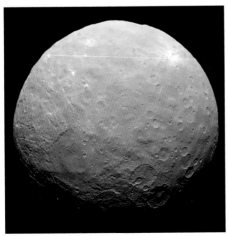

Ceres is the largest object in the asteroid belt, but like all others appears as a point of light.

RECOMMENDED ASTEROIDS FOR BEGINNERS

Name	Max Magnitude	Diameter (km)
4 Vesta	5.2	525
2 Pallas	6.5	540
7 Iris	6.7	200
6 Hebe	7.5	185
3 Juno	7.5	230
18 Melpomene	7.5	140
15 Eunomia	7.9	270
8 Flora	7.9	125
9 Metis	81	190

Simulated view of Jupiter (with the Galilean Moons) as seen with a telescpoe close to opposition.

Jupiter

The Solar System's largest planet is arguably its most compelling, with a dynamic and colourful face. For many, including the author, it's a firm favourite. Its powerful storm systems are just one part of its appeal; Jupiter is a system in its own right, with four large satellites – the Galilean Moons – which can be seen even with binoculars.

Jupiter is situated on the outer edge of the asteroid belt, where it orbits the Sun every 4,333 days (11.86 years) at an average distance of 778.5 million km. Were it a terrestrial planet like Venus or Mars, we

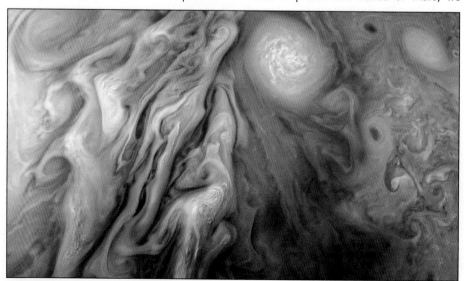

Jupiter's colourful storms are ever-changing, but many features persist over long timescales.

probably wouldn't spend much time looking at it. Fortunately, it's a giant, 11.2× wider than the Earth and capable of subtending up to 50 arcseconds in the sky. Even at its maximum distance from us on the far side of the Sun, it is never much smaller than 30 arcseconds. Whether at opposition or not, Jupiter is always an impressive sight and its largest features are always visible.

The 'surface' of Jupiter visible to us is a complex arrangement of cloud layers at varying altitudes. The planet's atmosphere is composed mostly of hydrogen and helium, but traces of water, ammonia, methane and silicon-based compounds form droplets and crystals that produce a wide variety of colours. Convection of heat from lower layers into the upper atmosphere, combined with the planet's rapid rotation rate (just under 10 hours) arrange the clouds into belts of various speeds, cyclones and anticyclones. The darker colours, such as brown and orange, are believed to be made up of phosphorus and sulphur or hydrocarbons, which change colour when exposed to the ultraviolet light of the Sun. The features are continuously changing, but there are stable structures, which have been observed for centuries. The various zones and belts of Jupiter, labelled in the image, are reliably present at all times, even though individual storms form and dissipate within them. The most obvious visual features are the northern and southern equatorial belts – dark horizontal lines around the paler equator – and the Great Red Spot (GRS), a monstrous anticyclone that churns up the southern equatorial belt. This storm alone is larger than planet Earth, although it has become progressively smaller over the past century. Astronomers believe that the vortex driving this storm is unlikely to disappear, and that the reduced size of the GRS reflects increased cloud cover that is somewhat superficial. Hopefully as you read this, the GRS is still alive, because it is one of the absolute highlights of the Solar System.

There are other notable features that tend to be overshadowed by the GRS. White ovals occasionally emerge in and around the temperate belts. In exceptional seeing, they may also be seen in the relatively dark polar regions. The equatorial and temperate belts can host brown barges, which sometimes look like beans or mitochondria. Occasionally they are very dark, strongly seen

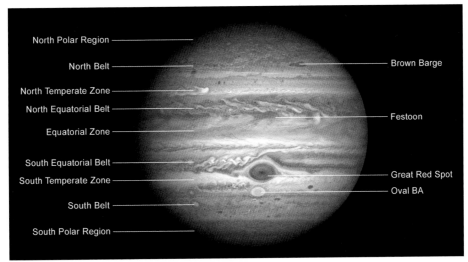

Jupiter features labelled.

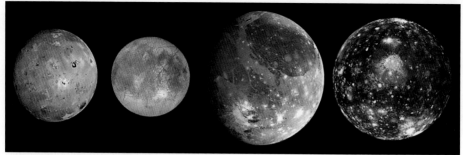

The Galilean Moons from left to right: Io, Europa, Ganymede and Callisto.

against the rest of the disc. Generally, white ovals are more common in the southern hemisphere and barges are more common in the northern hemisphere.

The author's favourite Jovian features are called festoons, which appear to pour out of the northern equatorial belt into the equatorial zone. They are delicate, painterly strokes of cloud that shimmer into view when the seeing steadies. What makes them really special is their extraordinary colour. Festoons are typically blue, and sometimes vividly so, contrasting spectacularly with the warmer colours Jupiter is known for. They look almost like waterfalls crossing the boundary from one belt to another.

Jupiter's rapid rotation carries its features in and out of view quickly. If the GRS is located on the western limb when you start observing, it will be in plain view an hour later. You can use WinJUPOS to accurately forecast the position of the GRS at any given time, but know that software cannot give you an exact impression of how Jupiter will look.

THE GALILEAN MOONS

Jupiter's four largest satellites – Io, Europa, Ganymede and Callisto – can be seen easily in binoculars and small telescopes, flanking the giant planet. They are all comparable in size to our own Moon, and many times smaller than Jupiter, but with a medium-

Name	Diameter (km)	Orbital period (days)	Description
Io	3,660	1.769	The most volcanically active world in the Solar System, Io's yellow surface is covered with sulphur.
Europa	3,122	3.551	An icy moon containing a warm salt-water ocean that may be habitable. The smallest of the Galilean Moons.
Ganymede	5,268	7.155	The largest moon in the Solar System, Ganymede has its own subsurface water mixed with layers of ice.
Callisto	4,821	16.69	Almost exactly the same size as Mercury, Callisto has the oldest and most heavily cratered surface in the Solar System.

sized telescope of about 6″ aperture they can be resolved as non-stellar discs. In smaller instruments, they appear as stars. The table contains information about each of the Galilean Moons, from innermost to outermost.

At the time of publication, Jupiter has 80 known moons, most of which are irregular rocks captured from the asteroid belt. The fifth largest moon, Amalthea, is substantially fainter than any of the Galilean Moons at magnitude 14, making it difficult to observe in the bright glare of Jupiter.

The visibility of the Galilean Moons varies continuously. At times you will see all four, sometimes pleasingly arranged with two on either side of Jupiter. At other times you may see all four on one side. It is less common, but hardly rare, to see only three moons or in some cases just two. In this case, you are observing Jupiter during a transit, occultation, or both.

TRANSITS AND OCCULTATIONS OF THE GALILEAN MOONS
Jupiter's axial tilt is very slight at just 3 degrees from the ecliptic. The orbits of the Galilean Moons are also quite closely aligned to the planet's equatorial plane, and so we can often witness them passing in front of, or behind Jupiter's disc. When one of the moons passes behind Jupiter, it is said to be an occultation. With sufficient magnification, you can watch the moon disappear behind Jupiter's eastern limb and re-emerge from the western limb. If a moon passes in front of Jupiter, it is in transit. In small telescopes, it is often difficult to see the disc of the moon with Jupiter immediately behind it – the planet is simply too bright. However, during many transits, a perfect circular black spot will be cast onto Jupiter's cloud tops – the eclipse shadow of a Galilean Moon. All four moons are capable of casting shadows, with Callisto being the least likely to do so. Transit shadows are perfectly black and extremely conspicuous on Jupiter's disc. They are visible in small telescopes at medium to high magnification and move from the west to the east. When Jupiter is not at opposition you can see shadows before or after transits begin or end, as the Sun angle is not directly behind you. The Java Jupiter calculator, hosted on the Shallow Sky website, allows you to predict and animate upcoming transit events, as well as see the shadow locations in relation to the GRS. You can also time transits and occultations accurately in Stellarium.

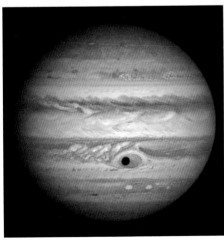
A transit shadow appears as a dark spot.

SUGGESTED FILTERS
As with Mars, Jupiter is a varicoloured planet that is well suited to a range of planetary filters. Blue (#80A), dark blue (#38A) and light blue (#82A) filters are particularly strong performers, with the standard blue being the favourite. This filter significantly darkens the appearance of the GRS against the equatorial belt, making it appear more prominent. At the same time, the blue filter lightens the appearance of festoons in the equatorial zone, which are otherwise quite challenging to observe. Other filters with warmer shades will variously suppress and emphasise different flavours of Jovian storms and belts, so it's worth trying them

Simulated view of Saturn (with Titan) as seen with a telescope close to opposition.

Saturn

When it comes to favourite planets, Jupiter and Saturn tend to assert themselves as the top contenders. While the largest planet offers colourful dynamic storms, dancing satellites and transit shadows, Saturn has something truly unique to show us – the Solar System's brightest ring system. Saturn isn't the only planet with rings; Uranus, Neptune and even Jupiter have been shown to host them too. But Saturn's are unlike all the others. Made up primarily of water ice, they mirror the Sun's light back into the inner Solar System to dramatic effect. It's not hard to see why so many people crown Saturn the jewel of the Solar System.

out and making your own notes to see which is most pleasing for you. Light red (#23A) is an underrated Jupiter filter, which darkens blue features such as festoons or rare blue ovals, and can improve the visibility of the Galilean Moons when in transit, darkening them against the brighter planetary disc. Baader's Moon & Skyglow filter is generally considered to enhance Jupiter's details and colour contrast.

The orb of Saturn is not to be overlooked. At nearly 9.5× the dimeter of the Earth, it's a giant planet with or without its rings. The distances between the giant planets beyond the asteroid belt are far greater than between the inner, rocky planets. Saturn is well over a billion kilometres from the Sun – 1.434 billion on average – and takes 29.5 years to complete one orbit. At this great distance, it varies in apparent size between 14.5 and

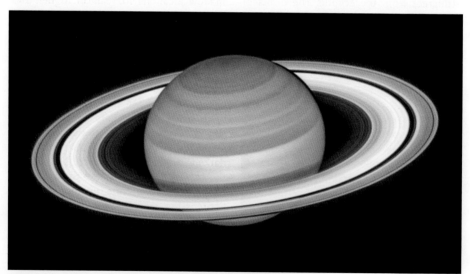

Saturn's unique rings are one of the wonders of the Solar System.

20.1 arcseconds, and is therefore always smaller than Jupiter. The rings, however, do increase its apparent diameter substantially, with the brightest spanning 47.4 arcseconds when Saturn is at its closest. The globe of Saturn has a very similar composition to Jupiter, but appears relatively featureless, with no persistent storms visible in a small telescope. However, it does show visible banding, which can be enhanced with the use of filters, and it is sometimes possible to see clouds. On rare occasions, bright storms do erupt on Saturn without warning, and may persist for weeks or months. In 2010–2011, a turbulent, global storm thrilled observers, as it wrapped around Saturn's northern hemisphere. Saturn's cloud tops are subtly shaded, but overwhelmingly yellow-brown in colour. The rings may show some colour in the eyepiece, but this is usually due to atmospheric scattering, as they are primarily white or grey.

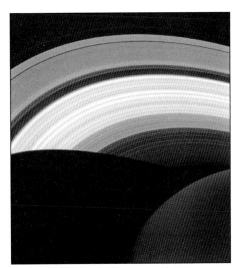

The Cassini Division dividing the A and B rings.

Saturn's rings are composed of ice – mainly water ice – but are not themselves solid. They are best considered a very flat cloud of orbiting particles, which vary in size from a few centimetres up to a few metres. Astronomers divide the rings into many small groups, each denoted alphabetically. As beginners using smaller telescopes, we primarily see the A and B rings. The A ring is the larger and slightly fainter of the two. With larger telescopes, it is possible to see the faint C ring, which is inside the B ring, and the narrow F ring, which is outside the A ring.

Saturn has an axial tilt of 26.7 degrees, which means it experiences seasons and changes its apparent angle throughout its orbital period. Around the Saturnian solstices, the rings are said to be open. We look across either the northern or southern face of the rings, and they are very conspicuous. Either side of opposition, we can also see the shadow of Saturn's globe cast onto its rings. During the Saturnian equinoxes, the rings briefly appear razor thin – they are closed. The appearance of the rings continuously oscillates and takes 7.5 years to change from open to closed or vice versa.

Between the A and B ring is a prominent gap called the Cassini Division. Best seen under steady seeing, it is visible with telescopes of 70 mm aperture or more using medium-high magnifications of 80× or higher. The Cassini division is approximately 4,500 km wide and whilst it is not really empty, it appears that way due to its very low density.

SATURNIAN MOONS

At the time of publication, Saturn boasts the largest number of known moons in the Solar System at 83. It is expected that many more 'moonlets' are hidden within the rings. The largest moon is Titan – a remarkable world in its own right. It is the second largest moon in the Solar System (after Jupiter's Ganymede) and the only moon to have a significant atmophere, which shrouds its surface. We know from infrared and radar observations that Titan's surface hosts lakes of liquid methane, which are pressurised by its nitrogen atmosphere at very low temperatures. It's probably not

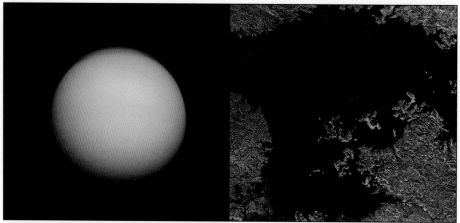
Titan's hazy atmopshere obscures its surface, but radar observations have revealed it to have liquid methane lakes.

suitable for active biochemistry, but Titan makes us think again about the viability of moons as potential habitats. Were it not orbiting Saturn, Titan would be considered a small but very interesting planet.

Titan is visible as a magnitude 8 star alongside Saturn in large binoculars and small telescopes. With larger telescopes, more moons can be found, including Rhea, Dione, Enceladus and Tethys. Saturn's moons are not as bright as Jupiter's, and they can get lost in the glare of the planet and its rings, but image techniques can make them much more visible. Even if Titan is the only moon you can see, it is still a spectacular sight, particularly when you imagine how strange and unique it is in combination with the one-of-a-kind ring system. During Saturn's equinoxes, Titan can on very rare occasions cast a transit shadow on the globe of Saturn, offering a great challenge for advanced Solar System observers.

SUGGESTED FILTERS
The use of filters is popular with Saturn, because it has a surprisingly complex but subtle cloud structure. Blue (#80A) and green (#58) are capable of improving the contrast of the cloud bands, which wrap around the orb of the planet. Blue and light

blue (#82A) are effective at brightening extraordinary storms when they appear. The otherwise rather underutilised yellow-green (#11) filter is worth consideration, as it is sometimes reported to improve the contrast of the Cassini Division.

The Ice Giants

Far beyond Saturn, in the coldest reaches of the planetary region, lurk the Ice Giant worlds – Uranus and Neptune. We will consider them together as a category, because their characteristics are quite similar. At their tremendous distances from us, neither planet offers a particularly clear view in a small or even medium sized telescope, but there are rewards to be found by those willing to take time to study them.

URANUS
Situated at an average distance of 2.871 billion km from the Sun, Uranus at its very best just barely spans over four arcseconds. It's a large planet by terrestrial standards, at four times the width of the Earth, but not large enough to reveal details in smaller telescopes. Even with large telescopes, a very skilled eye or high-sensitivity camera is required to observe

Simulated view of Uranus as seen with a telescope.

Features on Uranus are extremely subtle and hard to spot.

features in its blue-green cloud tops. Remarkably, despite its distance, Uranus is bright enough to be visible to the naked eye, varying in apparent magnitude from 6 to 5.4. It is seldom numbered among the 'naked-eye planets' but it technically does belong among them. Trying to spot Uranus by eye, much like trying to spot the asteroid Vesta, requires knowing exactly where to look, very dark skies, and the use of averted vision. To the eye, no colour is visible, but with binoculars it has a pallid, blue hue. In telescopes, Uranus shows a more subtle blue-green shade, which more accurately illustrates the concoction of ices, including water, ammonia and methane, that float in its hydrogen- and helium-rich atmosphere.

Larger aperture telescopes make the Ice Giants appear much more vibrant, as the brighter images engage the blue- and green-sensitive photoreceptors in our eyes. They also reveal moons. Uranus hosts 27 moons, all of which are unconventionally named after characters from the works of William Shakespeare and Alexander Pope. Typically, the four or five brightest moons are readily observable with large telescopes – those with apertures of 8″ or larger. They are Miranda, Ariel, Umbriel, Titania and Oberon.

NEPTUNE

Neptune is comparable to Uranus in size and composition, but it lies much farther away at 4.5 billion km from the Sun. Its angular diameter isn't affected much through the year, as our path around the Sun represents such a small fraction of the total distance to Neptune. The disc spans between 2.2 and 2.4 arcseconds. The pronounced blue colour is easy to identify with binoculars or a telescope, and quite striking with a large aperture, but there is

Simulated view of Neptune (with Triton) as seen with a telescope.

little to no detail to be seen visually without a very large instrument. Neptune is not without its weather systems – bright clouds and dark spots are known to manifest in its cloud tops on a regular basis, and we have detailed reconnaissance of them from the *Voyager 2* spacecraft, which visited Uranus and Neptune in 1986 and 1989, respectively. It is possible to capture and reveal these features using planetary imaging techniques, and perhaps see them by eye with a very large telescope at very high magnification, but as a beginner, the more rewarding challenge is to find Neptune's largest satellite. Of its 14 known moons, Triton is the only one that can be easily observed. Shining at around magnitude 13.4, it is within reach of a 6″ telescope or larger, and has a maximum angular separation from its host planet of 16 arcseconds. It appears as a star no matter the magnification, so take care to check its position and differentiate it from any background stars in the field of view.

Both Ice Giant planets show a slight increase in contrast with the use of yellow (#12), light yellow (#8) and yellow-green (#11) filters.

Neptune appears tiny to us, but its blue colour can be striking.

Pluto

It would be unkind not to include the former planet Pluto in our observation roster. Originally discovered using photography in 1930, it is a fun challenge to observe visually. Pluto is a tiny world, smaller than our Moon, which is physically quite similar to Neptune's moon Triton. During its perihelion, it is actually closer to us than Neptune at 4.44 billion km from the Sun. Pluto's last perihelion was in September 1989, and it is now steadily moving away towards its

Pluto (circled) appears as a very faint star.

aphelion distance of 7.38 billion km, which it will reach in February 2114. As such, Pluto becomes slightly trickier to see with each passing year, as it becomes fainter. It is still relatively close to its maximum apparent brightness at about magnitude 14, so you can see it with a 6″ telescope or larger. With an angular diameter of about 0.1 arcseconds at best, it will forever appear as a star in the eyepiece, but thankfully NASA's *New Horizons* probe revealed it, and its moons, in glorious detail in 2015.

6: MORE TO SEE

In this section, we will look at some of the other sights in our Solar System, including special events. For the sake of brevity, not everything here is covered in extensive detail, but by using further resources you can get started exploring these phenomena.

Comets

Beyond Pluto's domain in the Kuiper Belt lies the Scattered Disc, and beyond that a hypothetical swarm of comets surrounds the entire Solar System. Ancient icy boulders, they drift around on astonishingly long-period orbits, undetectable to even our most powerful telescopes. But, occasionally, one of these comets will be set on a path that takes it deep into the planetary region, for a close approach to the Sun.

Comets are generally discovered by survey telescopes or dedicated amateur comet hunters when they are very faint. Using follow-up observations, astronomers determine their orbital elements to predict if and when they may become visible. Most comets do not reach the threshold of naked-eye visibility, but some do. Once in a generation, a bright comet can be seen suspended in the sky in one or both hemispheres. Every 100 years or so, a truly great comet adorns the heavens, with a tail stretching across a vast swathe of the sky. The behaviour of these one-time visitors from beyond the uncharted outer Solar System is only partially predictable. They are volatile by nature, sometimes erupting and becoming tremendously bright, sometimes fizzling out. In general, if a superb, bright comet is going to become visible, you will hear about it in the press, but you can

Bright comet C/2020 F3 (NEOWISE) produced a tail that was visible to the unaided eye, even in light-polluted locations.

Several short-period comets, such as 41P/Tuttle–Giacobini–Kresák show a pronounced green colour.

follow the progress of all potentially visible comets at The Sky Live website, found in the Resources section.

There are also a number of short-period comets that are available to observe in binoculars or telescopes when they reach their peak brightness, which can be tracked on the Comet Watch website. Few of them will ever produce visible tails, but on occasion it is possible to observe a pronounced green colour. This is due to the presence of diatomic carbon (C_2) in the gaseous atmosphere (coma) that emerges from the cometary nucleus, which fluoresces green when energised by radiation from the Sun.

SUGGESTED FILTERS

Comet viewing with a telescope may be improved by the use of filters that pass green light. The gases in the comas and tails of most comets are green in colour, with strong emissions from doubly ionised oxygen (at 501 nm) and diatomic carbon (at 511 nm and 514 nm). With a large aperture telescope, a narrowband filter that isolates these wavelengths will draw out the comet from the background sky and potentially reveal more structural detail in its tail. Lumicon manufactures a dedicated comet filter designed to pass these wavelengths and block others. Alternatively, the Visual OIII filter from Baader will perform similarly as it delivers a narrow bandpass around 502 nm. Most comets are gassy in nature, but a small fraction are dusty – they do not fluoresce as strongly and will not respond as well to filters.

Meteor Showers

Every day, the Earth collides with millions of small fragments of material crossing its orbit. A fraction of them are large enough to burn up with a flash of light as they strike the atmosphere at hypersonic speeds. During the day we don't see them, but at night they cause sporadic meteors. Comets which regularly orbit the Sun release clouds of debris in their wake – icy grains and fragments usually no larger than a small pebble. If the Earth orbit coincides with a debris stream from a comet, a meteor shower will occur. There are many annual meteor showers that can be seen every year, starting as we enter the debris stream and ending as we leave. The stream density increases as we move closer to the comet's orbital path, and there will be a short period of much higher meteor activity (called the peak) for each shower.

Meteor shower performance is evaluated by counting rates using radio receivers and visual observations (crowdsourced from volunteers around the world). Astronomers allocate a number, called the zenithal hourly rate (ZHR) to illustrate the ideal theoretical number of visible meteors per hour. This is not a real number – observed rates will always be lower – but you will see press outlets running with it, which leads to false expectations. Each shower appears to originate from a point in the sky called the radiant. The ZHR assumes the radiant is immediately overhead at midnight, at New Moon and with ideal sky conditions.

The constellation that the radiant falls in usually determines the name of the shower. It may also be given a Greek letter if the radiant lies close to a bright

Meteors streak away from the shower radiant and travel to other parts of the sky.

Name	Dates	ZHR	Parent Comet	Speed (km/s)
Quadrantids	1 – 10 Jan	120	2003 EH1	41
Lyrids	16 – 25 Apr	18	C/1861 G1 (Thatcher)	48
Eta Aquariids	19 – 26 May	55	1P/Halley	66
Alpha Capricornids	11 Jul – 10 Aug	5	169P/NEAT	23
Perseids	13 Jul – 26 Aug	100	109P/Swift–Tuttle	58
Delta Aquariids	12 Jul – 23 Aug	16	96P/Machholz	42
Alpha Aurigids	Aug – Oct	10	C/1911 N1 (Kiess)	66
Southern Taurids	7 Sep – 19 Nov	5	2P/Encke	28
Northern Taurids	19 Oct – 10 Dec	5	2004 TG10	29
Orionids	4 Oct – 14 Nov	25	1P/Halley	67
Leonids	5 – 30 Nov	15	55P/Tempel–Tuttle	71
Geminids	4 – 16 Dec	120	3200 Phaethon	35
Ursids	17 – 23 Dec	10	8P/Tuttle	33

star with the corresponding designation. The table outlines the strongest annual meteor showers, indicating when they are visible. Each year, the International Meteor Organisation publishes a calendar with predicted peak dates and times, which vary due to the solar calendar and (in some cases) known irregularities in the shape of the debris stream. The most spectacular showers are highlighted.

There is no advantage to using magnification when viewing meteor showers – in fact, it will restrict your view. They are best seen with the unaided eye. Meteors appear stochastically and you should aim to continuously observe a wide area of the sky, either around the radiant or overhead where it appears darkest. Generally, it's best to be out during the hours of 00:00-02:00 local time, but some showers appear better in the hours before dawn if the radiant rises late.

Fireball meteors outshine even Venus at its brightest, and sometimes leave persistent trains in the sky.

Meteors range in brightness and contrast, so fewer are visible in light-polluted skies. Rarely, a super-bright fireball meteor will appear, with a magnitude brighter

than −3. These are unforgettable and visible regardless of light pollution or moonglow. Some meteors, particularly fireballs, leave trails in the sky called persistent trains. They are formed by ionised particles in the atmosphere still cooling after the meteoroid entry, and can be seen visually for anywhere from a fraction of a second to several seconds. It is also possible to see colours in a meteor as it burns. Different elements radiate different colours when burning, and vibrant meteors are usually varicoloured as a result. The most common meteor colours are caused by magnesium, nitrogen, oxygen, iron, calcium and sodium.

Cyan	Magnesium
Red	Nitrogen/Oxygen
Yellow	Iron
Violet	Calcium
Amber	Sodium

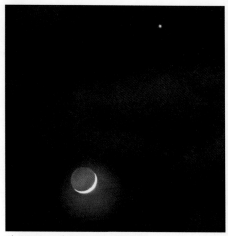

The Moon and Venus in conjunction.

Meteor showers can be captured photographically by a 'hands off' approach. Simply leave your camera pointed at the sky with a relatively wide lens and use an intervalometer to take continuous long exposures. You can review your shots after the shower and keep those which contain meteors. Meteor trails are not uniform lines – such trails are caused by satellites. Meteors brighten, sometimes flicker and suddenly burn out.

Conjunctions

As the planets and the Moon stay close to the ecliptic, passing through the zodiacal constellations, they will regularly meet each other. When two objects are in close proximity and share the same right ascension, a conjunction occurs. We tend to be more relaxed about the definition of a conjunction, however, by referring to any reasonably close approach of two planets or the Moon. When superior planets are near the start or end of their apparition, they will frequently be visited by the faster-moving Mercury and Venus in the sky.

Two naked-eye planets in close conjunction appear as a stunning 'double star', which can be quite colourful if it involves Mars

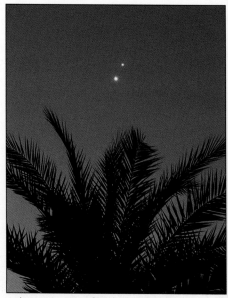

A close conjunction of brighter Venus and fainter Jupiter.

or Saturn. The slow-moving Ice Giants will also form conjunctions, but binoculars are required to see them. Less frequently, three planets may be close enough to form a small triangle – a spectacular triple conjunction.

The Moon in its rapid motion across the sky creates regular 'lunar-planetary conjunctions', the most beautiful of which occur around the New Moon period. A crescent Moon showing earthshine alongside one or two planets is a sight that can be enjoyed surprisingly often, and will regularly make the news. You can use the In-The-Sky website to generate a list of upcoming conjunctions for the year, and the dates on which to look for them. Use Stellarium to confirm the local time when the conjunction will be visible to you. Note that the smaller the separation, the finer the conjunction will appear.

The Moon and planets will also form conjunctions with bright stars and other objects in the zodiac. Notably, every eight years, brilliant Venus comes into conjunction with the Pleiades star cluster in Taurus. It seems to become a temporary

Venus passes in front of the Pleiades once every eight years.

member of the cluster. The last of these events before publication (pictured) occurred in April 2020.

GREAT CONJUNCTIONS

The rarest planetary conjunction visible to the naked eye involves both Jupiter and Saturn. Such events occur once every 20 years, with the last before publication

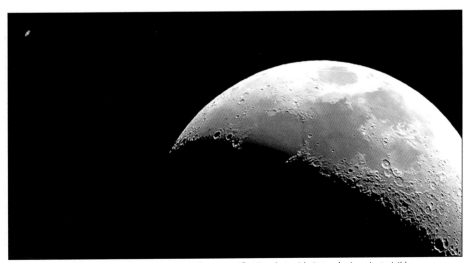

A conjunction of the Moon and Saturn, seen at low magnification, but with Saturn's rings just visible.

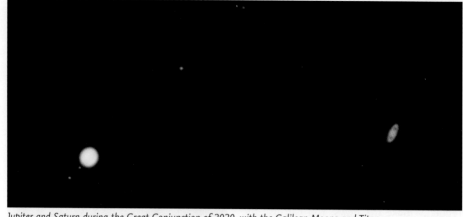

Jupiter and Saturn during the Great Conjunction of 2020, with the Galilean Moons and Titan visible in the eyepiece together.

(pictured) in December 2020, when the pair were separated by just over six arcminutes. The next two Great Conjunctions (2040 and 2060) will be over one degree apart, but in March 2080 the Gas Giants will pass each other by six arcminutes again.

Lunar Occultations

Lunar-planetary conjunctions are commonplace. On much rarer occasions, the Moon will pass directly in front of a planet as seen from a certain range of locations on the Earth's surface. These occultations are very time-sensitive events, which are best enjoyed using a telescope. The International Occultation Timing Association (IOTA) provides online resources for predicting lunar occultations including the Occult software, which you can find linked in the Resources section.

For any given part of the Earth's surface, lunar occultations are quite rare. The Moon is sufficiently close to us that we see parallax of its declination depending on where we are. For this reason, two observers at different latitudes will see the occultation differently, with those at the extreme edges of the occultation 'track' seeing a grazing occultation.

Satellites

When gazing at the night sky, you will often see stars apparently moving slowly in straight lines. These are satellites reflecting sunlight, and whilst they are not naturally occurring, we can reasonably consider them to be part of the Solar System. Many satellites are shown in Stellarium, with the positions predicted using calculations from their orbital elements. An increasingly large number of satellites is filling (and brightening) the night sky, as corporations utilise low Earth orbit (LEO) to sell satellite internet. Whether you enjoy seeing them is a matter of personal taste, but these enormous constellations of satellites increase the risk to astronauts and future space missions.

Among the many thousands of small satellites there are some significant objects in low Earth orbit, with the largest and brightest being the International Space Station (ISS). NASA intends to maintain the ISS in orbit until 2031, when it will be deorbited after decades of service to space science. NASA's future plans focus on building a station in orbit around the Moon, which will be difficult to observe, so it is worth making the most of the sight of the ISS whilst you can.

The Moon just prior to occulting Venus in the daylit sky.

Integrated photographs reveal a flurry of satellite trails during a period of a few minutes.

The International Space Station's vast solar arrays reflect ample sunlight towards us when the angle is favourable.

The ISS makes passes from west to east that usually last several minutes. It will eventually fade away as it passes into the shadow of the Earth, or the large solar arrays cease to reflect sunlight at the right angle for you to see. Its highly inclined orbit makes favourable, overhead passes possible for most of the Earth's population. NASA's Spot the Station service, linked in the Resources section, can show you upcoming passes from your location, when to look and how high they will appear in the sky.

By eye, the ISS is a bright point source that can outshine Venus. It moves quickly, so observation with a telescope designed to track it isn't easy, but should you see it in your telescope's field of view – even if by accident one night – you will be able to resolve the superstructure of science and habitation modules, as well as the gigantic solar arrays.

Many more satellites of varying significance can also be observed, and their circumstances can be predicted by calculator on the Heavens-Above website, linked in the Resources section.

Earth Shadow

We see the circular shadow of the Earth projected onto the Full Moon during a lunar eclipse, but it's not necessary to wait for an eclipse to see evidence of the shadow. The shadow can be observed as a dark band over the horizon just after sunset or before sunrise. In the eastern sky after sunset and the western sky before sunrise, a pink band – the Belt of Venus – is seen when sunlight that has been filtered through the atmosphere is backscattered towards us. Beneath this band, a dark blue region reaches down to the horizon. This is the edge of the Earth's umbral shadow being cast through its own atmosphere.

The shadow can be admired on any clear morning or evening provided you have a fairly unobstructed horizon, and it is best seen from high altitudes.

An ISS trail reveals its path across the sky.

The shadow of the Earth appears as a dark blue band opposite the rising or setting Sun.

Zodiacal Light and Gegenschein

Zodiacal light and gegenschein are two related phenomena that allow us to see an otherwise invisible facet of the Solar System. They are only experienced in moonless skies, free of light pollution, and are best seen from tropical or equatorial latitudes.

ZODIACAL LIGHT

Looking east before dawn around the local autumnal or fall equinox, or looking west after sunset around the local spring or vernal equinox, you may see a faint cone or triangle of light pointing into the sky. It appears almost like the light of the Milky Way but can seem brighter and more focused. This is zodiacal light, sunlight scattering off grains of dust that permeate the inner Solar System. The grains are tiny and rarefied, but cover a vast volume of space, rendering them collectively visible against the darkness of the sky.

The shape of the zodiacal light reflects the broadly flat structure of the Solar System – it is formed close to the ecliptic, within the zodiacal constellations, because the dust grains orbit in a flattened disc (which formed from the solar nebula as outlined in Section 2). Zodiacal light is shown well in photographs, but appears very faint to the eye. You will need to keep your eyes adapted to the dark by avoiding direct light sources. The zodiacal light appears strongest around the equinoxes, because the angle of the ecliptic to the horizon is steepest at these times. In the tropics and near the equator, the ecliptic is always steeply angled to the horizon, so there are more chances to see zodiacal light.

GEGENSCHEIN

Gegenschein (German: 'counter-view') is an extension of the same phenomenon as zodiacal light, but is more rarely observed as it requires supremely dark skies. Because the dust grains surround us, reaching out beyond the orbit of Mars, we might expect to see a band of zodiacal light across the sky from one horizon to another. The band is unfortunately too faint to visibly span the sky, but there is a spot immediately opposite the Sun (the antisolar point) which can be bright enough to see around midnight. This is gegenschein – zodical light at the antisolar point. It is most readily visible from local autumn or fall to local spring, because the antisolar point at midnight is highest during the winter, but it will require pristine, dark and moonless skies to pick out. As with zodiacal light, it is revealed much more clearly in photographs.

Zodiacal light after sunset.

Gegenschein forms an anomalously bright patch of light in the midnight sky.

With a wide-angle lens, the Moon's face shows few fine details.

7: BEGINNER'S SOLAR SYSTEM IMAGING

Anything we can observe in the Solar System can also be captured on camera, and astrophotography is a challenging and rewarding hobby well worth pursuing if you enjoy being out under the night sky. With special techniques, which will be introduced in this section, we can exceed the performance of the eye and reveal much more colour and detail than we ordinarily see.

Basic Solar System Photography

The Sun, Moon and planets are generally bright enough to be easily captured using virtually any standard camera – even a smartphone. However, without the aid of a long telephoto lens, little to no detail will be visible. The Moon's phases can be discerned, as can the Sun's disc (including 'phases' during a solar eclipse) but will appear small with wide-angle lenses. Everything else

appears as a star. Such lenses are designed to capture an impression of what is seen by the eye, so features on other worlds are not the expected subject, but that doesn't mean we can't take meaningful Solar System photos with them.

Wide-angle lenses are ideal for capturing meteor showers, satellite passes and various phenomena related to the Earth's atmosphere, such as the shadow band, Belt of Venus and lunar halos. They can also be used to reveal the extent of the Sun's corona during a total eclipse, or the long tail of an exceptional comet.

A tripod should always be employed to enable longer exposures with lower ISO settings that minimise noise introduced by the sensor. Additionally, a remote shutter or intervalometer can be used to take shots without physically touching the camera. Some cameras also support control with smartphone apps over WiFi. Objects in the sky are sharp when the lens is set to its infinity focus setting, but you should be

RAW (CR2, NEF, DNG)

Colour depth

Number of shades per colour - 65,535 16-bit (smooth gradients)
Number of colour combinations - 281 trillion

JPEG

Colour depth

Number of shades per colour - 256 8-bit (colour banding)
Number of colour combinations - 16.7 million

Raw files vs 8-bit compressed files, such as JPEGs. You should aim to capture in a raw format.

aware that many lenses will focus slightly 'beyond infinity' by design. For best results, use your camera's live view feature and zoom the image to manually focus on a bright star, or the surface of the Moon.

When using a DSLR or Mirrorless camera to take still images, always ensure you are shooting in a raw format. In astrophotography it is essential to take images in the highest quality your equipment will allow. Raw files (CR2/3, NEF, DNG etc.) are essentially digital negatives, which preserve all the data gathered by the sensor, allowing for much greater latitude in processing images. Compressed files, such as JPEGs, sacrifice many shades of colour and brightness, as well as fine details, to reduce the file size. Even an excellent JPEG is significantly inferior to a raw file, due to its low bit-depth. JPEGs record colour information in 8-bit, resulting in a total 16.8 million possible colours to be represented. This seems like a lot, but raw files preserve about 281 trillion (!) different colours – far more than you can see on a digital screen, but plenty to work with at the processing stage.

If you have a telephoto lens, you can experiment with capturing surface details on the Moon (or the Sun with a proper full-aperture filter). A long lens is functionally no different from a short telescope, and ever more features become visible with longer focal lengths. However, in order to capture the full range of surface features in detail, and capture details on other planets, we need the magnification afforded by a telescope to resolve them.

The Moon captured with a smartphone through the eyepiece of a telescope.

Imaging with a Telescope

AFOCAL SMARTPHONE IMAGING

Before we think about attaching a camera directly to a telescope, it is worth exploring the possibility of taking photos through the eyepiece with a smartphone. Almost everyone feels compelled to try it after looking through a telescope, and modern smartphone cameras are exceptionally capable, even in low light conditions. Using any camera with its own lens to photograph objects through an eyepiece is known as afocal photography.

Initially, as with most aspects of astronomy, it's better to start at a lower magnification, and the Moon makes an accessible first target. It is generously bright, and presents the entire lunar disc in good detail at low power. If your telescope is not tracking, a low magnification view will also offer more time for trial and error, as the subject takes longer to cross the field of the eyepiece. If your telescope is tracking, ensure your subject is perfectly centred in the field, as this area of the image formed by the eyepiece is relatively free of optical aberrations.

We have seen that at magnifications typical for Solar System viewing, the exit pupil of the eyepiece is very narrow. When we peer into the exit pupil with our eyes, our vision is steadied effortlessly as our brains compensate for the movements of our heads. Human vision is perfectly stabilised, but our hands are far less steady. The problem is exacerbated by the need to touch the device to capture a photo. You will often find yourself perfectly lined up for a shot, only to spoil it when pressing gently on the screen of your phone. There are, however, some ways to overcome this problem, utilising extra equipment that has entered the market in response to the rise in popularity of smartphone photography.

A digiscoping adapter is an excellent tool for afocal photography. It allows you to pair your phone to an eyepiece for hands-free shooting, and line up the phone camera's lens to the optical axis of the telescope

An afocal photo of a comet taken with a smartphone.

A phone securely fitted to the eyepiece with a digiscoping adapter.

Volcano-top eyepieces are unsuitable for digiscoping.

for best results. Digiscoping adapters are available from a variety of manufacturers, but when purchasing one, you should consider the eyepieces in your collection. Not all eyepieces are useful for digiscoping. So-called 'volcano top' eyepieces – those with smooth sloping sides around the eye lens – are particularly unsuitable because digiscoping adapters cannot be secured to them. Most modern smartphones are large and quite heavy, and a secure pairing is essential to avoid dropping your expensive device. Check the specification of the adapter to ensure it is suitable for the size and design of your eyepieces, or contact a dealer for further advice. The US-based company Tele Vue manufactures an adapter specially designed for many of their own eyepieces, proving to be the most secure solution for that range.

Due to the high dynamic range and contrast of the Moon, Sun and planets against the sky, it is generally difficult for smartphone cameras to automatically determine the optimal settings. A common frustration in practising afocal photography, even with a digiscoping adapter, is the inability for many smartphone cameras to correctly focus and expose the lunar disc. 'Tap-to-focus' can also prove less than useful. Fortunately, there are ways to control the exposure and

focus settings more precisely, though not all smartphones allow such adjustment by default. If your device has a pro or manual mode in its camera app, you should enable this. If not, consider a third-party camera application designed around manual exposure control. Increasingly, smartphones allow you to capture raw image data in much the same way as dedicated cameras.

One final hurdle is vibration caused by touching the device. A simple way to overcome this is to enable a timer of about three seconds, such that any vibrations imparted when the timer begins will cease before the shot is taken. Alternatively, you can source an inexpensive remote shutter – usually operated by Bluetooth – which is compatible with virtually any modern smartphone. A secure digiscoping adapter, combined with a remote shutter and manual exposure control app will result in a very simple and gratifying start to telescopic astrophotography, and the results can be impressive.

PRIME FOCUS TELESCOPE IMAGING
Whilst an afocal setup is relatively cheap, the best results are achieved by converting your telescope into a functional camera lens. In this way, the telescope's optics directly focus an image onto the sensor of a camera without the use of an eyepiece. DSLR and Mirrorless cameras can be adapted to be inserted into the telescope focuser with the use of a T-Adapter and corresponding T-ring. The T-thread has become the industry standard for this system, and can often be found on Barlow lenses. You may be able to unscrew the lens element from your Barlow and use it as a non-amplifying T-adapter. The T-ring is specific to the lens mount system of your camera, and once attached enables your telescope to behave like a prime lens.

It is not uncommon to encounter problems when trying to focus a telescope with a

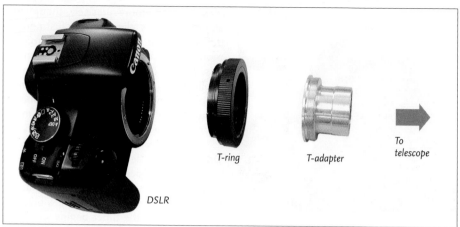

The T-thread system comprises an adapter and lens mounting ring.

camera attached. Camera sensors are situated at different positions inside the body, with DSLR sensors set farther back than mirrorless sensors. Pointed at a bright object like the Moon, adjust the focuser to find out which direction improves the image. If you need more distance from the telescope (backfocus), purchase an extension tube or use a star diagonal. If you need more travel towards the telescope (infocus) you will either need a camera with a sensor set farther forward, or a Barlow lens in front of your camera. The Barlow will add infocus but also increase the effective focal length of the telescope.

Image amplifiers are very useful for Solar System imaging, particularly for planets. As with eyepieces, we are concerned with sampling a small part of the field, and a Barlow or Powermate amplifier will increase the sampling resolution, which is typically measured in arcseconds per pixel. Of course, we can't have extra magnification at no cost. By doubling a telescope's focal length, we also double its focal ratio, which in the context of imaging is its photographic speed. An F/10 telescope operating at F/20 will be $20^2/10^2$ (400/100) or four times 'slower', photographically. This means images will appear four times dimmer for

a given exposure time. To capture surface details, we generally want to keep exposure times very short, so with image amplification, we will typically need to compensate using higher sensitivity, which will introduce more noise. In most cases, and with most modern cameras, a 2× Barlow will be perfectly suitable for improving the image scale. Consider sourcing a Barlow with a built-in T-thread for a more convenient setup.

Many generic Barlow lenses are pre-fitted with a T-thread.

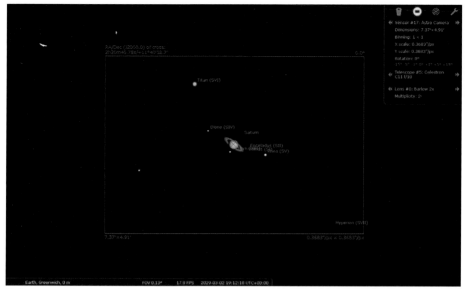

Stellarium can visualise the image scale of any telescope and camera combination.

Visualising Image Scale

The free planetarium software Stellarium contains an invaluable tool for visualising the field of view of a telescope-camera combination. Found in the upper-right portion of the display by default, or with the hotkey Ctrl/Cmd + O, the Ocular plugin can be configured to draw a red box illustrating the imaging field. In the settings window for the Plugin (found by clicking the spanner icon) you'll find pages for entering your own equipment specifications. You should enter your telescope's focal length and the details of your camera's sensor. Look up your camera on the manufacturer's website to determine the size (in mm) and resolution of the sensor on both axes. You can add your sensor to the list or modify an existing entry, but be sure to rename it so it is easy to find again. If your camera's sensor has built-in crop modes, consider adding these as separate listings. Most of our targets have a small apparent size, and cropping into the centre of the sensor can be helpful in reducing file sizes.

When the camera view is enabled, Stellarum will display the sampling resolution in arcseconds per pixel, and illustrate the scale of the image. You can also toggle image amplifiers (denoted lenses in the software) to see the effect of adding a Barlow or Powermate to your equipment. Note that Stellarium's simulated views of the Sun and Moon are not very detailed, but you can get a reasonable idea of how much of the disc will be captured in your images.

Image Capture Methods

UNDERSTANDING NOISE AND SEEING

Digital cameras are subject to digital noise being generated by the electronics of the sensor. For every 100 packets of light (photons) which arrive from space and land on our camera's sensor, there is a chance that the camera will record more than 100. These extra counts are digital noise, sometimes called dark current. Suppose we record 110 counts for every 100 real photos in an image. We would describe the image as having a signal-to-noise ratio (SNR) of 100:10 or, to reduce it to the smallest denominator, 10:1.

A single image of the Moon (left) is noisy and lacks detail compared with a 'stacked' image sequence (right).

For every 10 real bits of signal, we end up with one bit of noise. This noise is evident in digital photos, and particularly so when light levels are low. In very fast exposures with high ISO (or gain) settings, noise will be even more prevalent. The degree of noise is also dependent on the temperature of the sensor, which changes while it is in use.

Meanwhile, the appearance of the object in the telescope image is constantly changing as incoming light is perturbed by the moving air above us. Astronomical seeing alters the perceived geometry of the image (as well as blurring regions of it) such that for a given sequence of images, we cannot expect any to be perfectly representative of the true appearance of the subject. For example, the edge of a lunar crater will show a slightly different shape in several images captured just a fraction of a second apart, and none will correspond to the true shape. As observers, we build an impression of the shape over time as the seeing changes.

To overcome noise and the effects of seeing, we can capture sequences of many images and use software to construct a picture that looks far sharper and cleaner than any individual frame. Noise is rejected because it changes from one frame to the next, whereas real features are preserved. Meanwhile, the 'blurring' caused by the atmosphere is averaged out over time, and then removed using signal processing algorithms. This is the method used to obtain extraordinarily detailed images of the lunar surface, solar activity and other planets.

IMAGE SEQUENCES AND VIDEO

In order to obtain a large number of images quickly, it is usually easiest to simply record a video. There are drawbacks to this approach when using a DSLR or mirrorless camera, however, as the videos are typically compressed using a lossy method that sacrifices sharpness. Your camera may provide better video features, however, including a small central crop mode, capable of recording the very centre of the sensor in a low resolution and high framerate – typically

The crop video function is useful for imaging small targets.

around 640×480 at 60 frames per second. You should investigate your camera's video functions and experiment with filming at high magnification.

Alternatively, you can manually take sequences of images. This is generally useful when capturing the disc of the Moon or Sun, but less so with the planets. The best images require at least several hundred frames, and as such are obtained using high framerate videos. Conversely, the solar and lunar disc can be brought into sharp relief with just a few dozen photos. Consider taking as many as 80–100 for a better result.

Dedicated planetary imaging cameras are designed to be inserted directly into the telescope focuser.

DEDICATED 'PLANETARY' CAMERAS
As video is so popular for Solar System imaging, there are a number of dedicated cameras on the market, which record directly to a computer over USB. These cameras usually have small sensors, which sample at a fine scale, and are built to be inserted directly into the telescope focuser with an eyepiece-style nose barrel. They can easily be used with image amplifiers and filters, and often produce raw video files that preserve detail and colour information. In many cases, these cameras are offered with monochrome sensors. To create full colour

FireCapture is a popular tool for image capture with a dedicated astronomy camera.

images with monochrome astronomy cameras, it is necessary to take multiple videos in quick succession through coloured filters. This is an advanced technique, which is not covered in this book, but it is worth considering such cameras if your primary focus will be lunar or solar imaging. Greyscale data is perfectly suitable for these two subjects, and is particularly helpful when using certain filters. A narrowband solar telescope, for example, produces only one colour of light. For the Moon, a red or even infrared filter can be used to improve seeing and contrast. For Venus, a UV filter may be used to reveal atmospheric detail. If you are a beginner hoping to capture a wide range of objects, a 'One Shot Colour' (OSC) camera will be more convenient.

For cameras which are tethered to a computer, you will be offered capture software by the manufacturer. Most imagers prefer to go with feature-rich, third-party software like FireCapture, which has wide support for different camera models. It will enable you to control the exposure and record sequences whilst viewing the target live on screen. Be sure to record your videos in the AVI or SER format for later processing.

GENERAL ADVICE

When capturing image sequences at low magnification, it isn't necessary to use tracking, but when zooming in on apparently small targets, you'll need it to keep your subject in the sensor's field of view. You should aim to keep your exposures as short as possible without being underexposed. If the subject is dim, use a higher ISO (or more gain) to compensate, but beware if too much noise. The more noise is present, the more frames you will need to 'stack' later in order to clean up the image. This will incur a sharpness penalty. It will take a lot of experimentation and improvement to get the best settings for your combination of camera and telescope. Try to capture sequences of 500–3000

frames, which are preferably no longer than one minute in length. Jupiter in particular is not very forgiving, as it rotates quickly, and therefore the apparent positions of its visible features change.

Although raw images and sequences are large, you should organise and keep them backed up on a disc. You'll find that as you master your processing workflow, you'll be able to return to older data and produce better images.

Calibration and Stacking

To produce a clean image, we must 'stack' high-quality frames from our sequence. Before images can be stacked, they must be calibrated and evaluated. The calibration process determines the offset and quality of each frame, allowing them to be ranked and selected, before they are combined.

The most popular tools for performing these processes are called AutoStakkert! and Registax. AutoStakkert! is particularly effective, and supports compressed MP4 video files as well as AVI and SER files. If you have manually captured a collection of still images, you will need to join them into an image sequence – effectively a video – using the Planetary Image Preprocessor (PIPP).

Load your source and select 'Join Mode'. Choose to optimise for planetary, or solar or lunar close-up/full disc.

Under 'Processing Options' you can determine whether or not to crop the image. When capturing the whole of the Moon or Sun, it's advisable to crop out the black space around them, as this will increase the size of the raw file with no benefit. You can test the crop using the 'Test Options' button until it is suitable.

By default, PIPP will automatically centre the object in each frame, and reorder the frames

File Options Processing Help

Source Files Input Options Processing Options Quality Options Animation Options Output Options Do Processing

Image Files (121 frames) Dark Files (0 frames) Flat Files (0 frames) Flat Dark Files (0 frames)

Image Files List

Filename	Type	Frames	FPS	Size	Date	Filesize	Directory	
IMG_0384.dng	dng	1	-	-	03/01/2020 ...	24.28 MB	C:\Users\Tom\Desktop\Moon Images	n\
IMG_0385.dng	dng	1	-	-	03/01/2020 ...	24.28 MB	C:\Users\Tom\Desktop\Moon Images	n\
IMG_0386.dng	dng	1	-	-	03/01/2020 ...	24.28 MB	C:\Users\Tom\Desktop\Moon Images	n\
IMG_0387.dng	dng	1	-	-	03/01/2020 ...	24.27 MB	C:\Users\Tom\Desktop\Moon Images	n\
IMG_0388.dng	dng	1	-	-	03/01/2020 ...	24.28 MB	C:\Users\Tom\Desktop\Moon Images	n\
IMG_0389.dng	dng	1	-	-	03/01/2020 ...	24.28 MB	C:\Users\Tom\Desktop\Moon Images	n\
IMG_0390.dng	dng	1	-	-	03/01/2020 ...	24.28 MB	C:\Users\Tom\Desktop\Moon Images	n\
IMG_0391.dng	dng	1	-	-	03/01/2020 ...	24.28 MB	C:\Users\Tom\Desktop\Moon Images	n\
IMG_0392.dng	dng	1	-	-	03/01/2020 ...	24.28 MB	C:\Users\Tom\Desktop\Moon Images	n\
IMG_0393.dng	dng	1	-	-	03/01/2020 ...	24.28 MB	C:\Users\Tom\Desktop\Moon Images	n\
IMG_0394.dng	dng	1	-	-	03/01/2020 ...	24.28 MB	C:\Users\Tom\Desktop\Moon Images	n\
IMG_0395.dng	dng	1	-	-	03/01/2020 ...	24.28 MB	C:\Users\Tom\Desktop\Moon Images	m\
IMG_0396.dng	dng	1	-	-	03/01/2020 ...	24.28 MB	C:\Users\Tom\Desktop\Moon Images	
IMG_0397.dng	dng	1	-	-	03/01/2020 ...	24.29 MB	C:\Users\Tom\Desktop\Moon Images	
IMG_0398.dng	dng	1	-	-	03/01/2020 ...	24.28 MB	C:\Users\Tom\Desktop\Moon Images	

Add Image Files Remove Selected Files Remove All Image Files

Multiple Source Files:
○ Batch Mode
● Join Mode

Optimise Options For:
☐ Planetary ☐ Solar/Lunar Close-up ☐ Planetary Animation (AVI)
☐ ISS ☑ Solar/Lunar Full Disc ☐ Planetary Animation (GIF)
☐ AVI Archive

PIPP can be used to join images into an SER video file for stacking.

by quality (sharpness). Under 'Output Options' select SER and a location to save the file. Then, under 'Do Processing' click 'Start Processing' and wait for PIPP to create your image sequence.

When your video comes from PIPP or straight from your camera, you can load it into AutoStakkert! and begin the stacking process. Click the 'Open' button and load your sequence. You will need to select settings that suit the composition of your recording, and then hit analyse. You can find detailed guides for these settings

on the AutoStakkert! website. Note that colour images from dedicated cameras will be captured through a Bayer filter. AutoStakkert! will usually detect the correct deBayering setting, but if your image colours look strange in the preview window, you can manually fix it under 'Colour' at the top of the main window.

When analysis is complete, you will be able to enter a percentage or number of frames to stack, and add alignment points in the preview window. If you stack fewer frames, you'll get a sharper but noisier image. If you

PIPP's stabilisation and cropping function will reduce the file size of your image sequences.

Autostakkert! is used to analyse, align and stack sequences, rejecting poor quality frames in the process.

stack more frames, you'll get a cleaner but softer image. It's all about finding a good balance. Initially, try stacking at least 150 frames, but generally not more than 20% of the total number. If you are working with a manual sequence of stills taken at a lower magnification, you can probably include most of them – the best 70% or so.

When getting started, you can usually select 'Multi-Scale' and then 'Place APs grid' for a good alignment profile. Click 'Stack' in the main window and AutoStakkert! will eventually export a single image in TIF or PNG format. When you open it, you'll see that it appears blurry compared with a single

Autostakkert! alignment. Trial and error is essential to get the best results out of your data.

frame, but we are about to see the real magic of stacking.

Deconvolution and Final Adjustments

In order to reveal detail in stacked images, we assume that the atmospheric seeing – integrated over time – behaves like an image blurring algorithm. We can run an iterative reverse algorithm to 'unblur' the result. This process is called deconvolution.

Registax is an excellent tool for applying deconvolution. The software is also capable of calibrating and stacking frames, and you may find it to be preferable to Autostakkert! but in the author's experience, it is less intuitive and generally produces less favourable results.

Loading an image into Registax will take you directly to the 'Wavelet' tab. Wavelets apply deconvolution at different spatial scales, from coarse (layer 1) to fine (layer 6). They can be independently weighted with precise levels of sharpening and denoising. Using these sliders, you can achieve astonishing results.

You will find that adjustments are made only to a portion of your image, and you

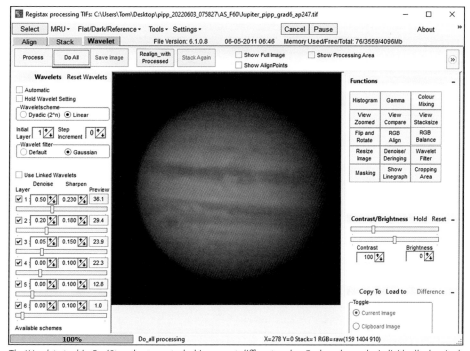

The Wavelets tool in RegiStax sharpens stacked images at different scales. Each scale can be individually denoised.

can change the affected area by clicking on the image. To apply your result to the entire image, you must click 'Do All'. Any subsequent adjustment will reset to the previous region of interest, so be sure to click 'Do All' again before clicking 'Save Image'.

It is also worth experimenting with the RGB Align tool if you are capturing colour images. This tool will correct the alignment of different colour channels, which may be offset due to atmospheric dispersion or chromatic aberration in the telescope optics. When applying deconvolution, the trick is not to go too far. Over-sharpened data has a very unnatural and plasticky appearance, and it's often a hallmark of a novice imager – the author was guilty of this many years ago! Aim for something that strikes a balance between natural and sharp, and when you are ready, export it as an uncompressed image file, such as a TIFF. You are now ready to make final adjustments.

Editing applications like Adobe Photoshop contain a suite of tools for finalising your images. The GNU Image Manipulation Program (GIMP) is a free alternative that is also fully-featured.

You can crop or rotate your image, or flip its orientation to counteract the effect of your telescope, and adjust its contrast levels using the curves tool. You may also wish to expand the black canvas around a planet if the image resolution is too low. Be aware that the apparently black sky in your image may not really be black, even if it appears so on your computer monitor, so ensure you set the black point correctly to avoid seeing a jarring outline on a monitor with a different calibration setting.

Be sure to save an uncompressed version of your final result, alongside a compressed JPEG for sharing with friends, or on social media. In this guide, we have seen the theory

Your sharpened image can be adjusted in any editing software, such as GIMP.

and process of producing sharp images of Solar System subjects. In practice, every object and every combination of equipment will require a subtly different approach, but understanding the general process (as well as why we choose this method) will enable you to progress quickly as you try your hand at different subjects. Welcome to the imaging community!

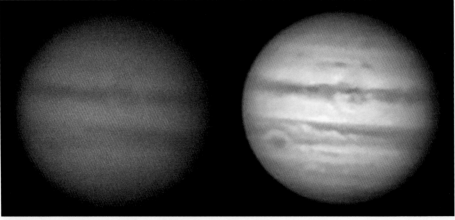

Comparing a single frame to the final, stacked, sharpened and colour-corrected image.

8: RESOURCES AND GLOSSARY

Software and Website Links

SOFTWARE
Stellarium – stellarium.org
Planetarium software featuring eyepiece and camera view simulation.

Virtual Moon Atlas – ap-i.net/avl/en/start
Detailed lunar atlas software for Moon observers.

Occult – lunar-occultations.com/iota/occult4.htm
Software for calculating timings and visibility of occultations.

SkytechX – skytechx.eu
Sophisticated planetarium software with 3D Solar System visualisation and chart rendering.

FireCapture – firecapture.de
Free capture tool for planetary imaging cameras that produces files for stacking.

PIPP – sites.google.com/site/astropipp
Planetary Image Preprocessor for cropping, stabilising or joining image sequences.

Registax – astronomie.be/registax
Alignment, stacking and deconvolution of videos and image sequences.

Autostakkert! – autostakkert.com
Alignment and stacking of videos and image sequences.

GNU Image Manipulation Program – gimp.org
Free image editing software for finalising stacked images.

WEBSITES
TheSkyLive – theskylive.com
Online planetarium with useful page about bright comets.

In-The-Sky – in-the-sky.org
Comprehensive suite of night sky calculators and information about upcoming events.

Heavens Above – heavens-above.com
Website for finding bright satellites passes.

Time and Date – timeanddate.com
Accessible information about solar and lunar circumstances, including eclipses.

7Timer! – 7timer.info
Worldwide weather forecasts with seeing and transparency.

SpaceWeather – spaceweather.com
News website with daily image showing visible sunspots.

FURTHER RESOURCES
Spot the Station – spotthestation.nasa.gov
NASA's own service for calculating when to look out for the International Space Station.

NASA Eclipse Information – eclipse.gsfc.nasa.gov
Detailed, printable charts of upcoming eclipses.

JPL Horizons – ssd.jpl.nasa.gov/horizons
The NASA data portal for generating ephemerides (tables of Solar System object positions).

International Meteor Organisation – imo.net
A comprehensive resource for meteor watchers, including a detailed meteor calendar published annually.

International Occultation Timing Association – occultations.org
A website providing information about upcoming occultations of planets and stars.

Glossary of Terms

Accretion
Accumulation of mass by a gravitationally significant object drawing in material from the surrounding region. Accretion discs form around young stars and black holes.

Afocal
An image system in which an eyepiece is used to project a magnified image into a camera lens.

Altitude
The separation between an object and the local horizon, measured in degrees from 0 to 90.

Aphelion
The point in the Earth's orbit at which it is farthest from the Sun. The Earth reaches aphelion in early July at a distance of 94.5 million miles from the Sun.

Apparent angle
The angle subtended by an object in the sky – measured in degrees, minutes and seconds – as it appears from the surface of the Earth.

Apparent field of view
The apparent diameter of an image formed by a telescope eyepiece, measured in degrees.

Arcminute
A measurement of angular size, which is one sixtieth of one degree.

Arcsecond
Equal to 1/60th of an arcminute and 1/3,600th of a degree, an arcsecond (or second of arc) denoted " is a unit of size or separation on the celestial sphere. Objects are said to subtend X arcseconds or be Y arcseconds apart.

Asteroid
A small, irregular body composed primarily of rock and metal, which orbits the Sun. Most asteroids in the Solar System occupy the Main Asteroid Belt, largely contained between the orbits of Mars and Jupiter.

Astronomical Unit (AU)
The average distance between the Earth and the Sun, equal to 92.96 million miles.

Atmospheric drag
A force acting on bodies travelling through an atmosphere, produced by collisions with gas atoms. Drag reduces the speed of orbiting bodies, ultimately causing them to fall.

Azimuth
The direction of bearing of an object in the sky, measured in degrees. North is 0 degrees; east is 90 degrees; south is 180 degrees; west is 270 degrees.

Bit-depth
A number denoting the exponent of possible shades between black and white in a digital colour channel. For example, an 8-bit RGB image contains 2^8 (256) shades for each channel, for a total of 16.7 million colour combinations. A 16-bit RGB image contains 2^{16} (65,536) shades for each channel, for a total of 281.5 trillion colour combinations.

Chromosphere
A region of the Sun's lower atmosphere, situated above the photosphere. The chromosphere is prominently revealed using a hydrogen-alpha solar telescope.

Comet
A small body composed primarily of ice and frozen gas, which orbits the Sun. Most comets originate from far beyond the orbits of the planets. Comets which approach the Sun undergo outgassing, growing long tails of debris in space.

Conjunction
An event in the sky in which two objects in the Solar System (or one such object and a star or deep-sky object) share the same right ascension in close proximity. More generally, two objects apparently close in the sky are said to be in conjunction.

Day side
The side of a celestial body illuminated by the Sun.

Declination (Dec)
Equivalent to latitude on Earth, a coordinate denoting the vertical position of an object on the celestial sphere. Measured in degrees, minutes and seconds both north and south of the celestial equator. The celestial poles are at 90 degrees north and south.

Dioptre	With binoculars, each eye lens can be set to a separate distance, altering its optical power (or dioptre) to compensate for minor differences that are common in most people's eyes. Typically, the dioptre must be adjusted to maximise viewing comfort.
Dwarf planet	An object in hydrostatic equilibrium (approximately spherical in shape) which orbits the Sun, but has not or cannot clear its orbit of significant debris. Ceres and Pluto are examples of dwarf planets. Both have the characteristics of small planets, but both share their orbital neighbourhoods with substantial amounts of material.
Eclipse, lunar	An event during which the Moon passes partially or entirely into the shadow of the Earth in space.
Eclipse, solar	An event during which the Moon passes partially or entirely across the face of the Sun as seen from a portion of the Earth's surface.
Ecliptic	A imaginary line tracing the apparent path of the Sun through the celestial sphere over one year. The ecliptic passes through the constellations of the zodiac. The Moon, planets and asteroids always appear close to the ecliptic.
Equinox	A point in the orbit of the Earth or other planet during which its axis of rotation is perpendicular to the direction of the Sun. There are two equinoxes in each orbit. The Earth's equinoxes occur in March and September.
Exit pupil	The diameter of the image formed by a telescope or eyepiece, typically measured in millimetres.
Exposure time	Measured in seconds – the length of time a camera's shutter is left open. Longer exposure times are used to collect more light for a brighter photograph.
Eye lens	The lens at the top of an eyepiece, which sits closest to the eye.
Faculae	Bright regions of energetic activity visible in the Sun's atmosphere. Faculae are particularly well seen using Calcium K-line filters.
Field lens	The lens at the bottom of an eyepiece, which sits closest to the telescope objective.
Focal ratio	The ratio of a telescope's focal length and objective diameter. A 100 mm aperture telescope with a focal length of 800 mm has a focal ration of f/10.
Geocentric coordinates	Coordinates for objects in the sky as seen from a point at the centre of the Earth.
Interpupillary distance	The distance between an individual person's pupils, measured in millimetres. A pair of binoculars employs a hinge for adjustable interpupillary distance.
Kuiper belt	A region of the Solar System beyond the orbit of Neptune, which extends from about 30 AU to 50 AU. Pluto is the most famous member of the Kuiper Belt, which is also home to many other small worlds.
Libration	An apparent 'wobbling' of the Moon, allowing us to peer around its eastern or western limb to observe a total of about 59 per cent of its surface. Libration occurs as the Moon changes speed in its non-circular orbit, but continues to rotate on its own axis at a fixed rate.
Lunar apogee	The point in the Moon's orbit where the centre of the Moon and the centre of the Earth are farthest apart.
Lunar perigee	The point in the Moon's orbit where the centre of the Moon and the centre of the Earth are closest together.
Lunar synodic month	The period of the cycle of lunar phases, measured from Full Moon to Full Moon, equal to 29.5 solar days.

Magnification	A measure of the scale factor for images formed by a telescope and eyepiece in combination.
Meteor	The flash of light emitted by a small object, such as a fragment of rock or ice, burning up in the Earth's atmosphere, commonly known as a shooting star. Meteors occur sporadically throughout the day and night.
Meteor shower	A period of elevated meteor activity which occurs when the Earth passes through a debris stream in orbit around the Sun.
Natural satellite	Also known as a moon, a natural object in orbit around the planet, dwarf planet or other significant body excluding the Sun.
Night side	The side of a celestial body not illuminated by the Sun.
Objective (lens or mirror)	The optical assembly in a telescope that collects and focuses light.
Occultation	An event in which one celestial object passes in front of another, covering it. The occulting object must have a larger apparent size in order to fully occult the background object.
Oort cloud	A vast region of the outer Solar System spanning a distance of about one light-year from the Sun. The Oort cloud is the source of long period comets.
Opposition	When the right ascension of an object is 180 degrees from the Sun, it is said to be in opposition. An object in opposition will be visible throughout the night, generally appearing at its brightest and largest, and will transit the local meridian at solar midnight.
Orbital elements	A collection of numbers used to characterise an orbit. Traditionally, six elements (known as Keplerian elements) are calculated by way of observation, such that the position of an object can be predicted in the future.
Orbital period	The time taken for an object to complete its orbit. For planets, asteroids and comets, this value is usually given in years. For moons, it is usually given in days.
Perihelion	The point in the Earth's orbit at which it is closest to the Sun. The Earth reaches perihelion in early January at a distance of 91.4 million miles from the Sun.
Photosphere	The dense 'surface' of the Sun, beneath its atmosphere. Details in the Sun's photosphere can be viewed with the use of a white light filter.
Planet	An object in hydrostatic equilibrium, which orbits the Sun, and which has cleared its orbit of significant debris. There are eight planets in the Solar System.
Precession	A gradual change in the orientation of the rotational axis of a celestial body. The Earth's axis rotation traces a circle due to precession once every 25,772 years.
Prime focus	A term denoting the use of a telescope as a photographic lens, without eyepiece projection. In this configuration, the camera sensor (or film) is placed at the focal plane of the telescope.
Prominence	An eruption of material in the Sun's atmosphere, which protrudes from the solar disc. Prominences are visible with the use of a hydrogen-alpha solar telescope.
Protoplanetary disc	A disc of material around a young star in which planets are forming. The Earth and other planets were once protoplanets in a protoplanetary disc surrounding the Sun.
Resolving limit	The minimum separation between two sources that can be individually resolved through a telescope, typically measured in arcseconds.

Right ascension (RA)	Equivalent to longitude on Earth, a coordinate denoting the horizonal position of an object on the celestial sphere. Measured in hours, minutes and seconds, where 24 hours represent a full circle. The location of 0 right ascension, called the First Point of Aries, is currently in Pisces and moving towards Aquarius.
Scattered disc	A large circumstellar disc of small objects overlapping and reaching far beyond the Kuiper Belt, spanning of over 100 light-years from the Sun.
Seeing	A measure of the effect of atmospheric turbulence on the steadiness of the appearance of the stars and other objects. Steady conditions are described as good seeing.
Sidereal month	The period of one sidereal lunar orbit, equal to 27.3 solar days.
Sidereal orbit	An orbit as measured with respect to a fixed position on the celestial sphere.
Solar corona	The extended atmosphere of the Sun, visible by eye briefly during the totality of a total solar eclipse. The solar wind comprises material escaping the corona into the Solar System.
Solar nebula	A large cloud of material from which the Sun and Solar System formed billions of years ago. Evidence for the composition of the solar nebula is found in the objects which make up the Solar System today.
Sunspot	A dark feature visible on the Sun's photosphere with a white light filter. A sunspot is a relatively cool region of the photosphere, where convection of heat is restricted by intense magnetic stress. Sunspots vary in number according to the solar cycle.
Terrestrial planet	A planet primarily made of rock and metal, without an extended atmosphere. In the Solar System, the terrestrial planets are Mercury, Venus, Earth and Mars.
Topocentric coordinates	Coordinates for objects in the sky which are specific to a point on the Earth's surface. For objects close to the Earth, such as the Moon, topocentric coordinates can differ markedly from geocentric coordinates.
Transit	An event in which one Solar System object passes in front of another with a larger apparent size. Mercury and Venus can transit in front of the Sun as seen from Earth. Jupiter's largest moons can cast shadows on the planet during a transit. A solar eclipse is a kind of transit.
True field of view	The true diameter of the field of sky visible in an eyepiece. An eyepiece with a 50 degree apparent field of view, magnifying the image by 100×, will present a true field of view of 0.5 degrees.
Wavelength	The distance between two wavefronts in a light wave, which determines the colour of the light. Measured in nanometres, visible light has a wavelength between about 400 nm (violet) and 700 nm (red.)
White light filter	A powerful neutral density filter designed to reduce the apparent brightness of the Sun to a safe level. A white light filter reveals the Sun's photosphere, making sunspots and other features visible.
Zodiac	A collection of 12 ancient constellations intersected by the ecliptic. The zodiac as long been admired for its connection to the Sun, Moon and planets, and was established as a calendar over 2,000 years ago.

Acknowledgments

5	Shutterstock / Pavel Dyachenko
7 *left*	© Tom Kerss
7 *right*	© State Office for Heritage Management and Archaeology Saxony-Anhalt, Juraj Lipták.
8 *left*	Shutterstock / Dimitrios P
8 *right*	Joshua Brown /Research Gate
9 *left*	Wikimedia Commons / Wellcome Collection
9 *right*	Wikimedia Commons
10	Wikimedia Commons
11 *top*	With kind permission of Lord Egremont
11 *bottom*	NASA / Istituto di Linguistica Computazionale
12	© Tom Kerss
13 *top*	© Tom Kerss
13 *right*	NASA
14 *top left*	NASA/JPL-Caltech
14 *middle left*	NASA/JPL
14 *bottom left*	Venera 13/Don P.Mitchell
14 *top right*	NASA
14 *bottom right*	NASA Ames
15 *top left*	NASA/JPL-Caltech
15 *bottom left*	NASA
15 *right*	ESA/NASA
16 *left*	NASA/Johns Hopkins University Applied Physics Laboratory/Southwest Research Institute/Alex Parker
16 *right*	ESA / Rosetta / Philae / CIVA / Mattias Malmer
17	NASA/JPL-Caltech/R. Hurt (SSC/Caltech)
18	ESO/L. Calçada
19	NASA
20	NASA/JPL-Caltech
21	NASA
22	shooarts/Shutterstock
24	Shutterstock
25 *top*	© Tom Kerss
25 *bottom*	Shutterstock / Jim Cumming
26–30	© Tom Kerss
32 *left*	Shutterstock / sruilk
32 *right*	Shutterstock / ILIA BLIZNYUK
33	© Tom Kerss
34 *left*	Shutterstock / True Touch Lifestyle
34 *right*	Shutterstock / Sergey Malkov
35	Gordon MacGilp
36 *right*	Shutterstock / AstroStar
36 *bottom*	Gordon MacGilp
37	Shutterstock / Allexxandar
38	Gordon MacGilp
39 *left*	DAVEnet
39 *right*	Shutterstock / Alexey_astrophoto
40	© Tom Kerss
41	Shutterstock / Louis Darp
42	© Tom Kerss
44 *left*	Shutterstock / Bogdan Steblyanko
44 *right*	© Tom Kerss
45–52	© Tom Kerss

53	Wikimedia Commons
54–57	© Tom Kerss
58	NASA
59 *left*	Shutterstock / DeepSkyTX
59 *right*	© Tom Kerss
60–62	© Tom Kerss
63 *left*	© Tom Kerss
63 *right*	NASA/Joy Ng
64	© Tom Kerss
65 *top left*	NASA
65 *bottom left*	NASA
65 *right*	© Tom Kerss
66	NASA/JPL-Caltech
67–68	© Tom Kerss
69 *left*	© Tom Kerss
69 *right*	ESA & MPS for OSIRIS Team MPS/UPD/LAM/IAA/RSSD/INTA/UPM/DASP/IDA, CC BY-SA 3.0 IGO
70 *top*	©Tom Kerss
70 *bottom*	NASA
72	© Tom Kerss
73	NASA/JPL-Caltech/Tom Kerss
74 *top*	© Tom Kerss
74 *bottom*	NASA/JPL-Caltech/SwRI/MSSS/Tom Kerss
75	© Tom Kerss
76	NASA/JPL/DLR
77	NASA/ESA/STScI/Tom Kerss
78 *top*	© Tom Kerss
78 *bottom*	NASA / ESA
79	NASA
80	NASA/JPL-Caltech/Tom Kerss
81 *top left*	© Tom Kerss
81 *top right*	NASA/ESA and Erich Karkoschka, University of Arizona
81 *bottom right*	© Tom Kerss
82 *top*	NASA
82 *bottom*	© Tom Kerss
83	© Tom Kerss
84	Shutterstock / Wisanu Boonrawd
85	Shutterstock / Travel.Life
86–88	© Tom Kerss
89 *top*	NASA
89 *bottom*	© Tom Kerss
90 *top*	NASA
90 *bottom left*	Shutterstock / StGrafix
90 *bottom right*	Shutterstock / longtaildog
91	ESO/Y. Beletsky
92–95	© Tom Kerss
96 *top*	Anthony Guiller E. Urbano (www.nightskyinfocus.com)
96 *bottom*	Shutterstock / Bogdan Steblyanko
97–98	© Tom Kerss
99 *top*	With kind permission of the ZWO Company https://astronomy-imagine-camera.com
99–104	© Tom Kerss

Specialist editorial support was provided by Emily Drabek-Maunder, Senior Manager, Public Astronomy at Royal Observatory Greenwich.

ACKNOWLEDGMENTS **111**

Author Biography

Tom Kerss F.R.A.S. is an astronomer, astrophotographer, author and consultant. Having previously worked at the Royal Observatory Greenwich, he is founder of Stargazing✦London, which delivers world-class online astronomy courses with experts. Tom is also the host of the Star Signs podcast, which features fascinating guests whose lives overlap with the stars. He is an avid stargazer and sky-chaser who is always looking for his next astronomy adventure. Find out more about Tom's projects and other books at **stargazing.london**